CHIPPING NORTON
THROUGH TIME

Chipping Norton
Local History Society

AMBERLEY PUBLISHING

Acknowledgements

These photographs are from the collection of the Chipping
Norton Museum of Local History. We would also like to thank
Alan Watkins and Pauline Watkins for photographing the modern
locations, and Brenda Morris and Elizabeth Whitaker.

First published 2009

Amberley Publishing Plc
Cirencester Road, Chalford,
Stroud, Gloucestershire, GL6 8PE

www.amberley-books.com

British Library Cataloguing in Publication Data.
A catalogue record for this book is available from the British Library.

ISBN 978 1 84868 289 4

Typesetting and Origination by Amberley Publishing.
Printed in Great Britain.

Introduction

It is always difficult deciding what to omit and what to include when compiling a book of photographs. Chipping Norton, in particular, is rich in its photographic records, having large, well-known collections from both Percy Sims and Frank Packer. In this book we wanted to present some of Chipping Norton's history in pictorial form, showing the changes that have taken place over the last hundred years. A town, like a breathing organism, expands and contracts, and amoeba-like, evolves into a creature seemingly removed from its origin. However, it is its past which informs its present and may affect its future. How many people in New Street for example, stop to consider the small shops which stood where now they walk, shops where previous generations gossiped and bought their provisions? Do the inhabitants of new properties ever think of the ghosts of those who once laughed, cried or loved in the buildings which preceded theirs?

Through these pictures we hope to encourage memories, curiosity and an awareness of our past. Inevitably we experienced problems when snapping the modern scenes. Unlike our earlier photographers, we cannot stand freely and safely at the junction of the Banbury and London Roads. To do so today would invite disaster at the wheels of the lorries thundering down to flow into the A44 sweeping into New Street towards the distant motorways. Trees and shrubs have grown up or have been replaced; so views are obscured and architecture adorned with stray greenery. Complete structures have disappeared and their replacements are difficult to photograph.

By our choices we have tried to capture the atmosphere of an earlier period and to awaken the memories of those still living. In recalling the shopkeepers, many of whom posed in front of their premises for their snapshot, we hope to stir the impressions and experiences of anyone whose parents visited them for sweets, or meat; clothing or buns, or perhaps to have a wedding

cake baked and iced to perfection...or maybe to simply gaze in on the way to school, a school which is very different from those we have in Chipping Norton today.

Much has been written about the history of the town and there are many publications relating to its inns and industries. This book has snippets of information which we hope, with its photographs past and present, will bring pleasure to all and nostalgic memories to anyone whose family lived and worked in this friendly, independent, proud little town of Chipping Norton.

Liz Whitaker

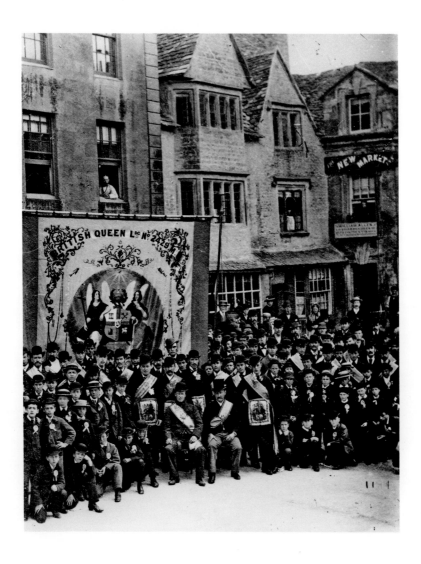

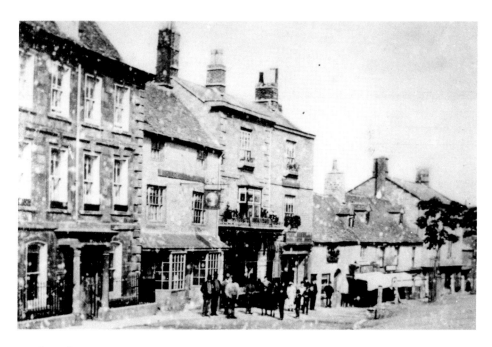

Market Place.

The picture shows the Stourbridge and Kidderminster Banking Company; the Borough Arms, and a butcher's shop. The bank and the Borough Arms were demolished but in 1885 the replacement still bears the name 'Old Bank'.

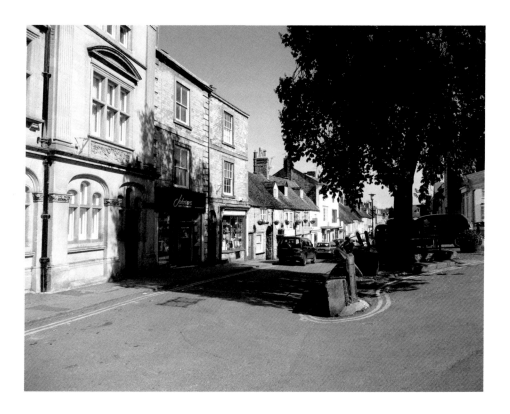

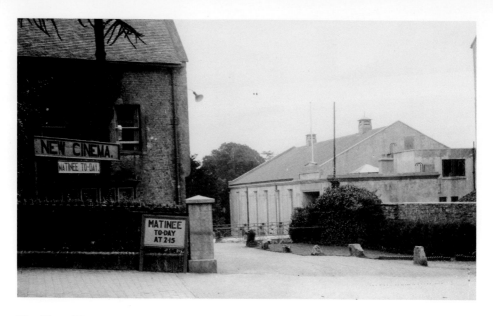

The New Cinema.

The New Cinema in New Street was built in 1934. It had several names over the years, The Ritz and The Regent being just two. It was a very large building with stage and lighting equipment. There were two programmes each week and, eventually, another programme on Sundays. Children were allowed to go on Saturday afternoons for 3*d*. The basement was used as an air raid shelter for New Street residents in the Second World War. The buildings were converted into squash courts after the cinema closed in September 1973.

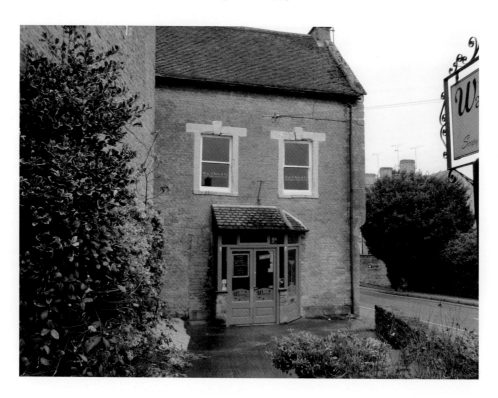

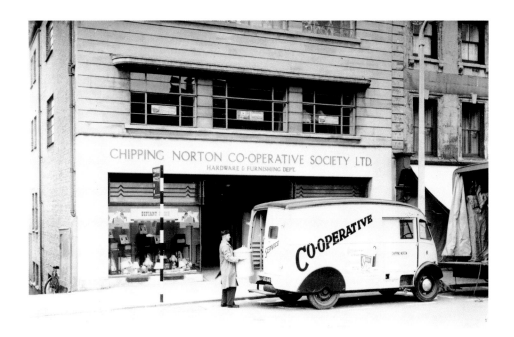

The Co-operative Society.

Chipping Norton Co-operative Society Hardware shop on Market Street next to Manchester House. Deliveries were made by van to all the surrounding villages. Charlie Robinson is the man loading a dustbin. The shop is now a hairdresser's.

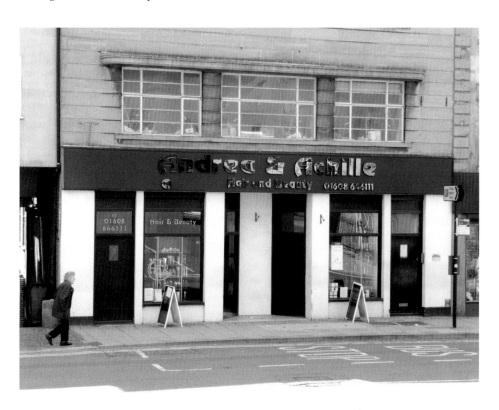

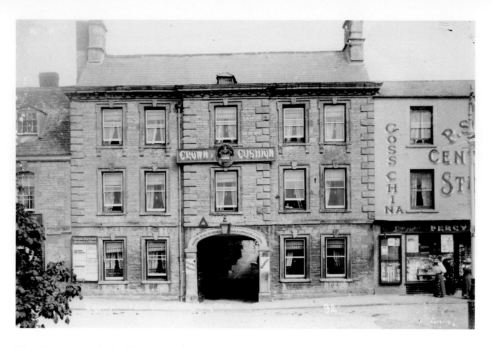

The Crown and Cushion Hotel.

The Crown and Cushion Hotel on High Street was formerly known as the Catherine Wheel. Note the open archway leading to the stables at the rear. The shop next to it belonged to the photographer Percy Simms. In the window are some of his postcards. The hotel frontage has been altered considerably.

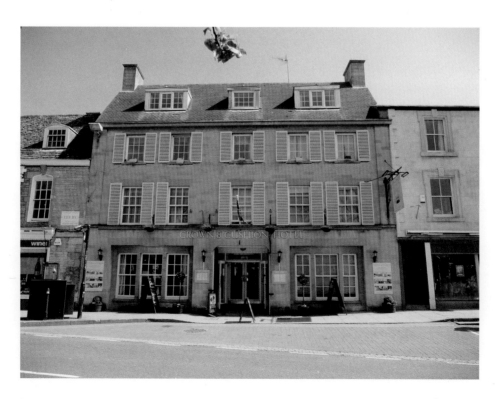

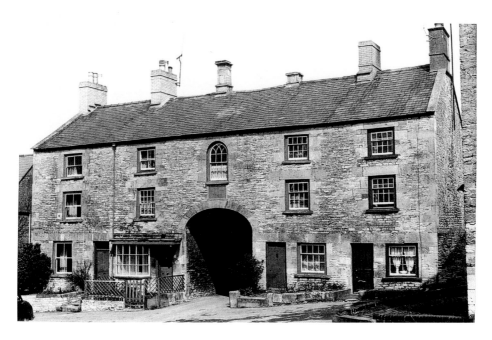

Finsbury Place in New Street.

Henry Greenwood had a large boot and shoe manufacturing business employing ninety-three men. He built Finsbury Place in 1854, named Finsbury after the area of London in which he had previously lived. Two houses were either side of the arch in New Street and in the 1940s these were occupied by Mrs Gibbs, Mr and Mrs Caswell, Mr and Mrs Sandles and Mr and Mrs Stanbridge. There were twelve three-storey cottages in the Place, which was reached through the archway, and four houses fronting New Street. These were condemned in the 1950s and pulled down. The ground was derelict for some years before the present houses and flats were built in Finsbury Place.

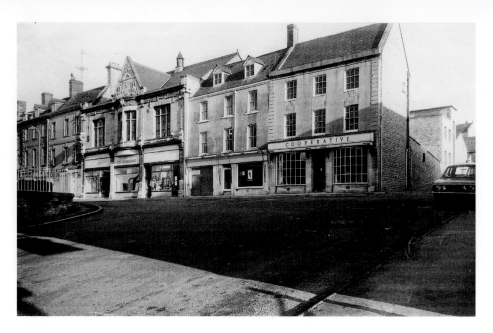

Chipping Norton Co-operative Buildings in High Street.
This picture shows the drapery and haberdashery store, the grocery and the Co-op restaurant. The restaurant was later turned into the first Co-op supermarket. The Co-op Hall in the centre was built in 1890 and now houses the Town Museum.

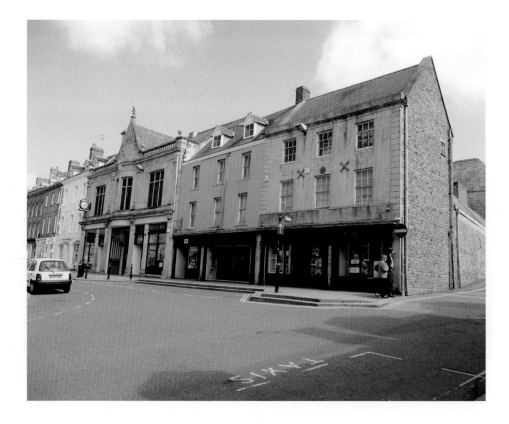

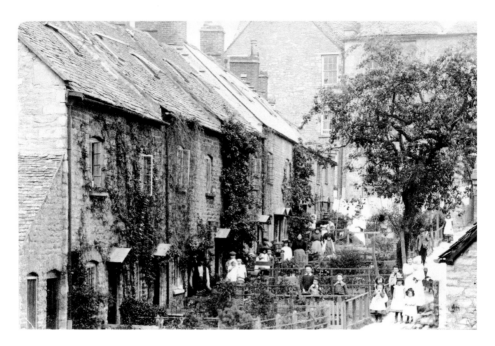

Kings Head Yard.

Kings Head Yard showing the houses on the left with their small front gardens. There were numerous small cottages in the yard at one time. These cottages were condemned in the late 1950s and the occupants re-housed in the new houses in Hailey Avenue. The cottages, however, were not demolished but were turned into garages. These were later turned into larger residences.

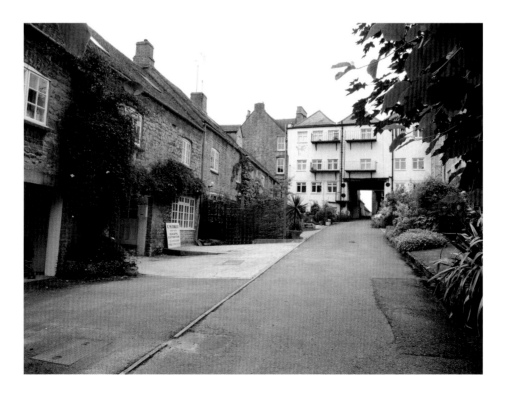

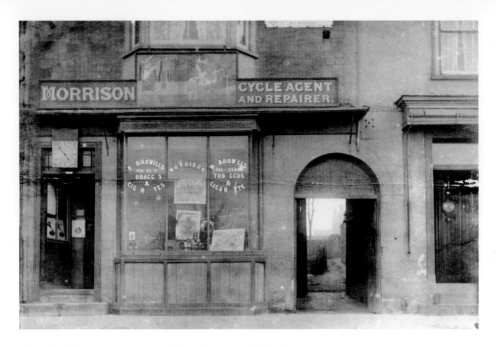

Morrison's Cycle Agent and Repairer on High Street.

In 1900 there was a disastrous fire and the shop was seriously damaged, together with the jeweller's shop of Mr D.R. Simms. The archway shown was in the centre of these two buildings and led to a yard, which extended from the High Street to Albion Street, or Back Lane as it was then called. The Black Boy Public House and twelve cottages were in this yard, water being supplied from a pump half-way up the yard. Mr D.R. Simms erected a new shop on the site, and, although he took the precaution of placing the front door and passage to the rear in exactly the same position that the original passage had occupied, there was no longer a right of way to Back Lane.

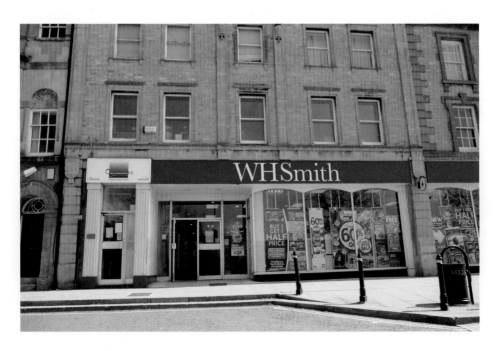

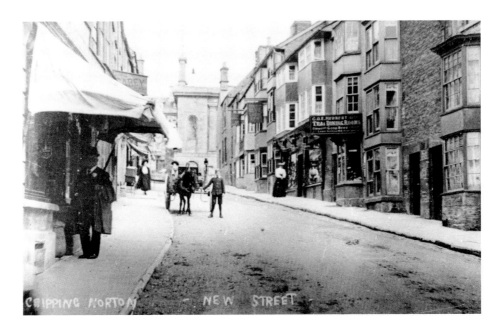

New Street.

The south side of New Street showing the Old George Public House, the Blue Lion Inn, and the King William Inn. Next came Mr Herbert with his fizzy drinks. Later this became Poppy Langton's. New Street was very narrow at this point, before the north side of the street was demolished for road widening in the 1970s. Note that the frontages of the buildings have not changed over the years.

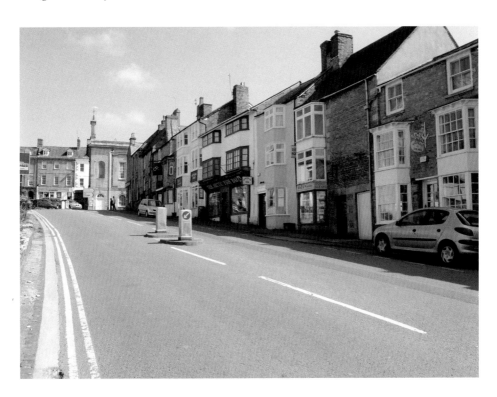

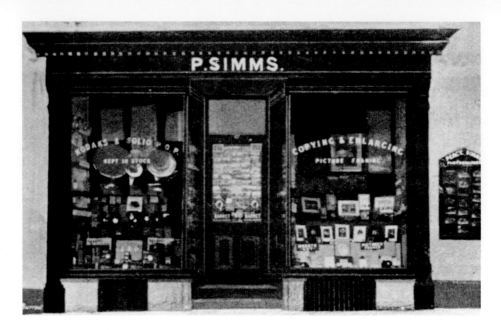

The Photographer's Shopfront at No.12 High Street.
Percy Simms had this shop at the beginning of his career. It later became the Pearl Insurance Offices.

No.10 High Street.

For a number of years this was the premises of George Hannis, high-class tailor. It was then taken over by G.T. Smith & Son who ran it as an electrical shop. It became Barker's and a succession of other shops before becoming Dorothy Perkins.

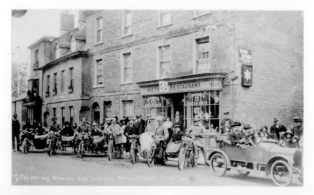

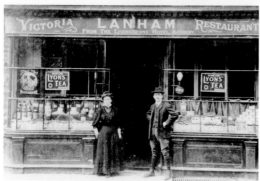

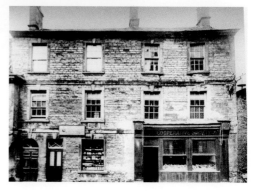

West Street.

Clockwise from above left, West Street. The Victoria Tearooms. Mr and Mrs Lanham are standing outside; *top,* the same restaurant in Edwardian times has a motorcycle rally outside; *right,* the Co-operative butcher's shop moved from the High Street to these premises. There was a slaughterhouse to the rear. Mr Woodhouse's jewellery shop is next door; *bottom,* the building later became Highlights before reverting to a restaurant called The Old Mill.

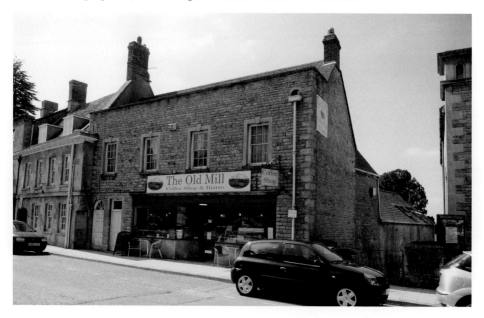

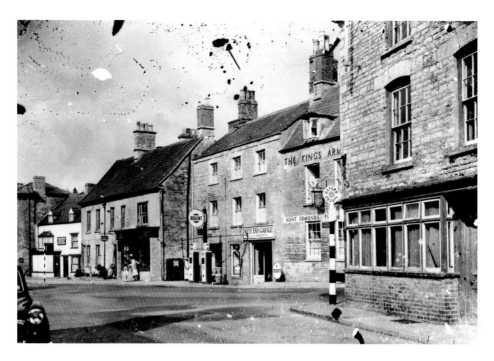

West Street showing the Kings Arms Hotel and Motts Garage.
The large building on the corner of Burford Road was the Liberal Club.

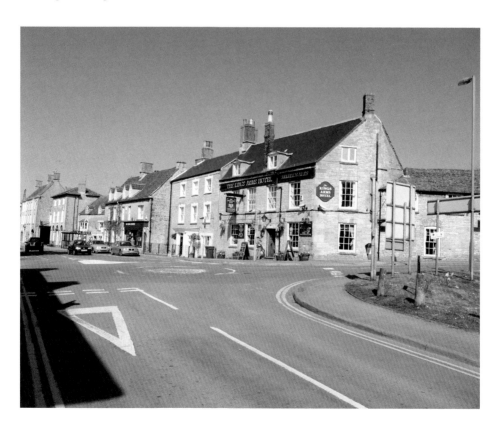

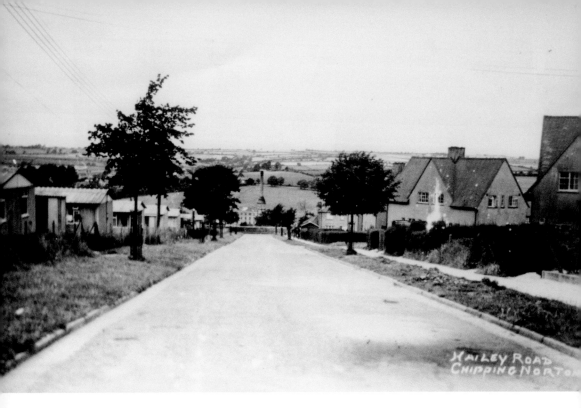

Hailey Road.

Hailey Road showing the prefabricated buildings on the left. They were built just after the war to last ten years, and were eventually sold off after twenty.

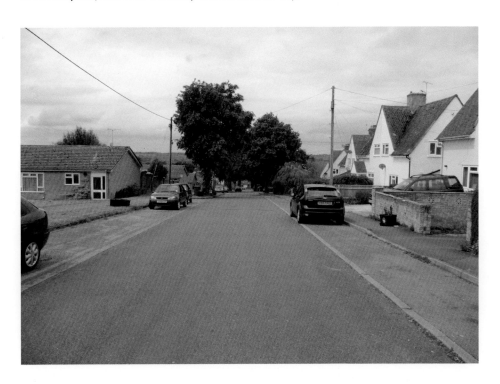

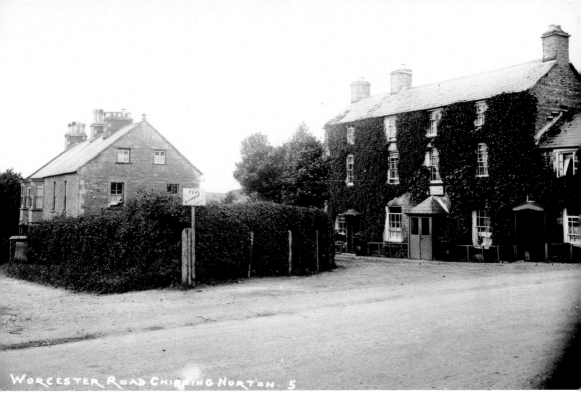

WORCESTER ROAD CHIPPING NORTON. 5

The Fox and Hounds Public House in Worcester Road.

The Fox and Hounds was granted a license to sell beer, porter and cider only, and was closed as a public house in 1958. It was a very popular place to call in at when walking over the fields on the way home on the circular walk from Chipping Norton to Salford. It is now a private house.

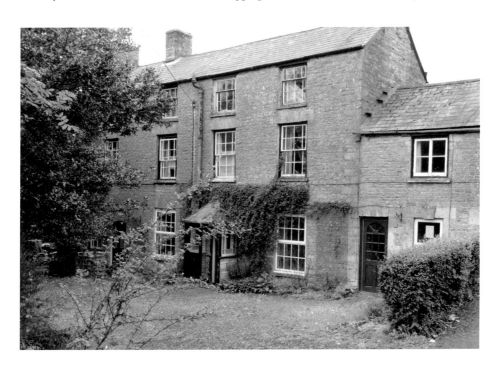

No. 25 New Street.

This was formerly a barn dating from the seventeenth century. It was in a commanding position looking down New Street towards the Common and was the home of Mrs Jim Shadbolt. In spite of widespread opposition, this house and the small shops on the north side were demolished in order to widen the road and pavement in the 1970s. The building to the side was used by Mr Henry Weston as part of his butcher's shop in New Street. In the 1940s, Mr and Mrs Stanbridge lived in the three-storey house on the left, at the top of Finsbury Place.

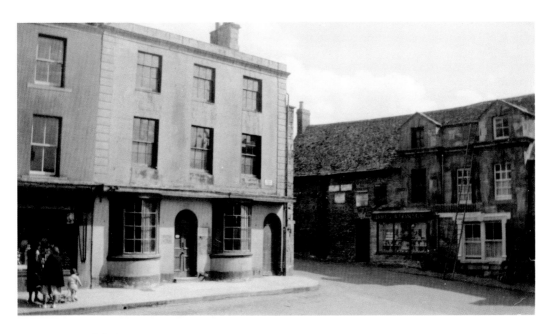

No. 1 High Street.

These were the offices of Wilkins & Toy, Solicitors, which were taken over by Farrant & Sinden. They were later renovated to make the Co-operative Tea Rooms and Restaurant. On the left is Atkinson's shop, which was a seed and corn merchants.

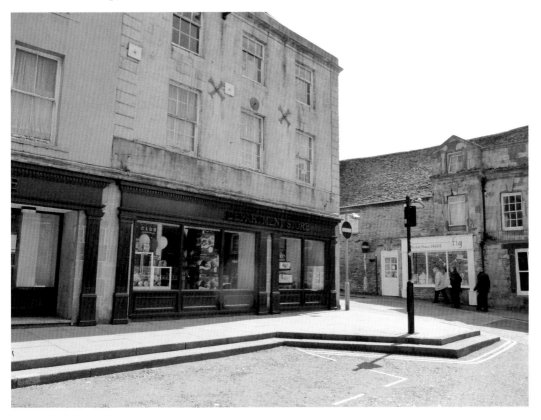

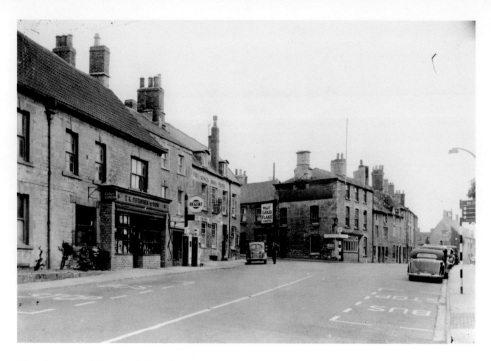

The Corner of Burford Road.

Another view showing the corner of Burford Road. Mr T.K. Pettipher's grocery shop is on the left. People passing were tempted in by the smell of the roasting coffee beans. Next door is the garage before the Kings Arms Hotel. The Liberal Club is on the corner behind the signpost. Mrs Bates' sweet and tobacco shop is next door. It was a favourite place for all the children going to and from school!

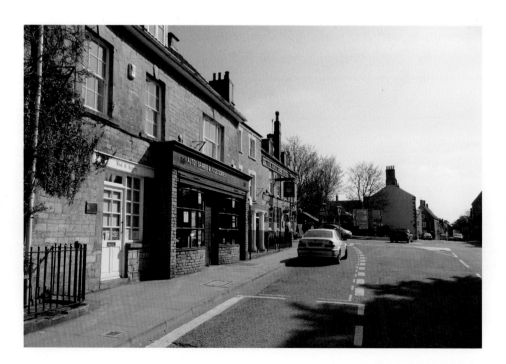

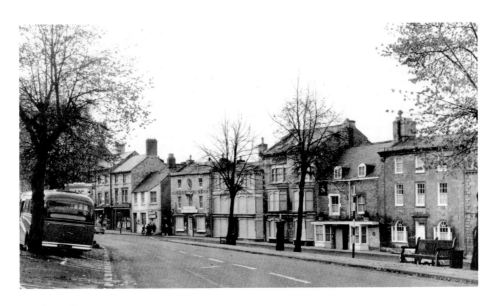

Market Place.

A general view of the Market Place. From the left hand side we can see the front windows of Messrs James Styles & Whitlock, Estate Agents. Mr Bignell's bakery and restaurant is on the right-hand corner next to the large department store of Messrs A.A.Webb & Sons. This shop sold everything one could wish for in Chipping Norton; clothing, haberdashery, drapery, toys, prams and pushchairs, furniture (new and second-hand) and china. It was very much missed in the town when it had to be knocked down for the New Street widening. Next to Webb's store is the sixteenth century Unicorn Inn which was also pulled down.

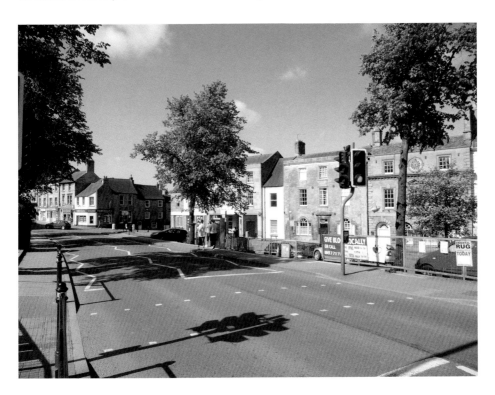

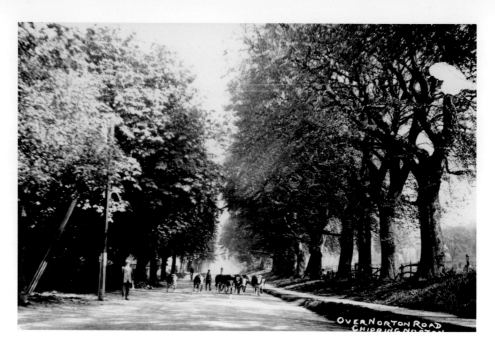

Over Norton Road.

A view of Over Norton Road showing cows being herded towards the town. The chestnut trees on the left conceal the entrance to the Townsend allotments that were cultivated until the early 1960s, when the land was sold for building.

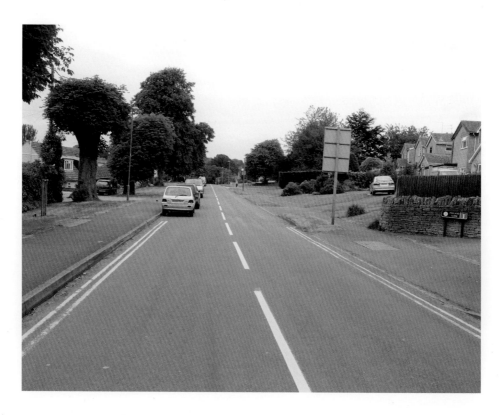

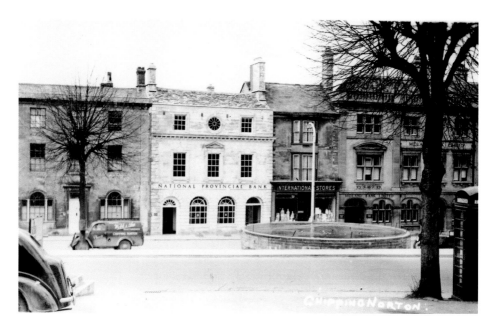

Market Place.

In the centre of the picture is the National Provincial Bank which was opened in 1951. Note the static water tank in the middle ground. Although designated a part of fire precautions during the Second World War, it wasn't used until after the war when there were fires in Middle Row and at the Town Hall.

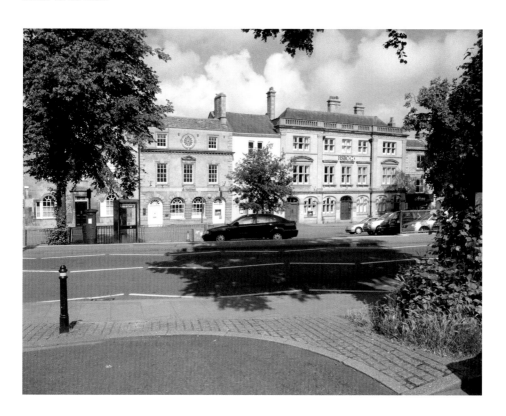

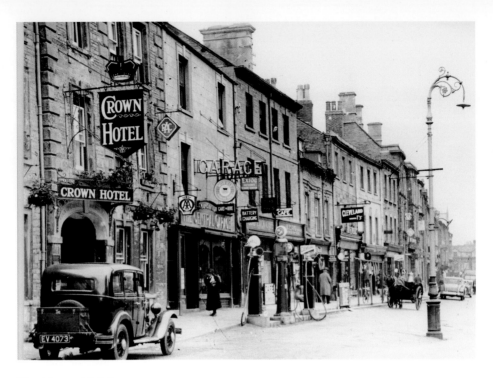

The Crown Hotel.

High Street showing the Crown Hotel with its open archway. Next door is the Central Garage complete with petrol pumps outside. The Good Luck café is next door to Hayes' paper shop. Notice the ornamental street lighting, so different from today's utilitarian fittings.

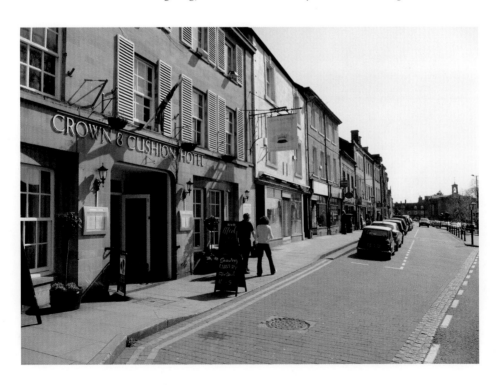

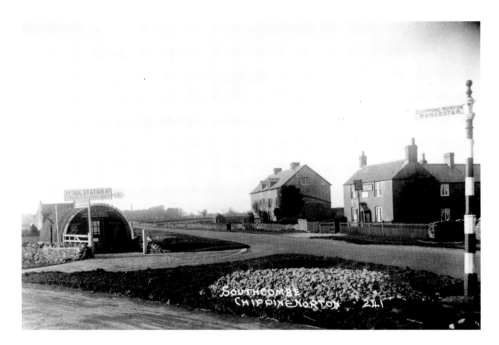

Southcombe.

Southcombe, showing Sumpter's Garage by the signpost. On the right-hand side can be seen four cottages, which are still there. The building on the right is the Quiet Woman Public House. This was demolished in 1959 and a new timber construction was erected in its place. This was completely destroyed in one hour by a spectacular fire on the 19 April 1967. The Quiet Woman was rebuilt on the same site but the chimney of the previous building was left standing; so this was incorporated into the new building. It was later closed as a public house and became a Happy Eater restaurant. It is now an antiques centre. There is still a garage on the site.

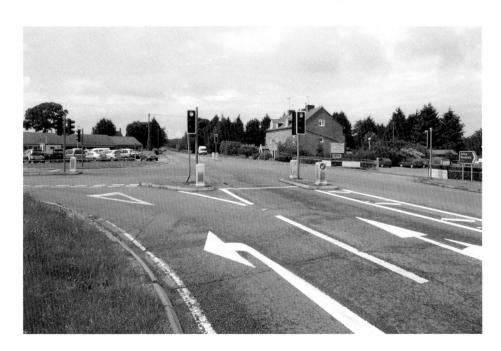

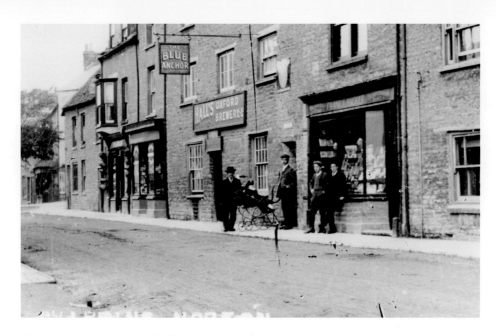

The Horse Fair, previously known as Pembroke Street.

The house on the left-hand side of the picture is now the Citizens Advice Bureau. Mr Lord had his bakery shop next door, baking at the rear of the building. The Blue Anchor Inn is now part of Harpers' DIY shop. The man standing with a baby's pram outside an archway probably lived in one of the four houses situated in Anchor Court, which has now been demolished. Frank Packer's photographic shop completes the picture.

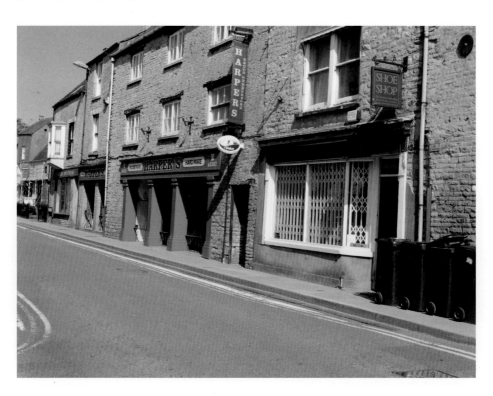

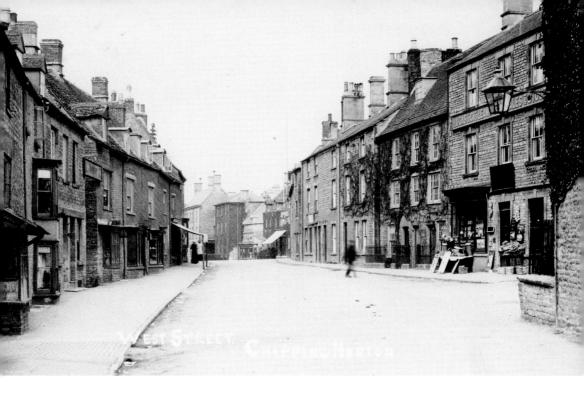

West Street.
West Street looking towards the Kings Arms.

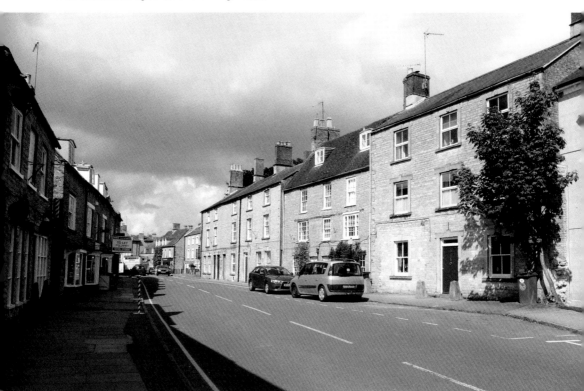

Market Place.

Market Place showing the top of New Street with scaffolding holding up the house of Dr and Mrs Latcham, after the removal of the old Unicorn Inn. On the left of the picture is the seed merchant's Walter Craft & Sons with Messrs James Styles & Whitlock Estate Agents next door.

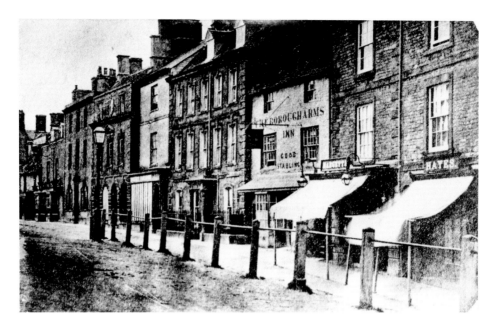

A Second View of the Market Place.

Market Place taken from the bank outside Jaffe & Neal's bookshop. This shows the International Stores grocery shop, a large town house and then Borough Arms Inn beside the butcher's shop belonging to Margetts. The town house and the Borough Arms were removed to make way for the building of the Midland Bank.

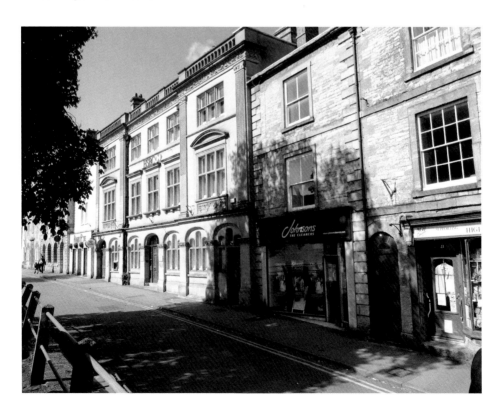

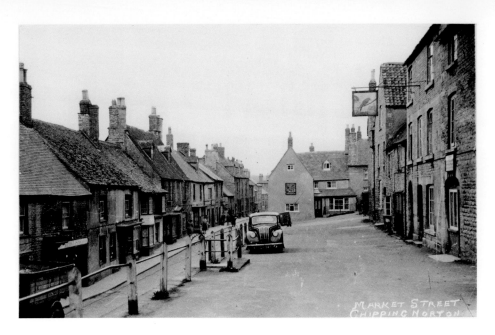

Church Street.

The left-hand side shows the buildings towards Church Street, which are domestic houses. The Chequers Inn is still much the same as today, but the Parrot Inn in Middle Row is now the Kingdom Hall for the Jehovah's Witnesses.

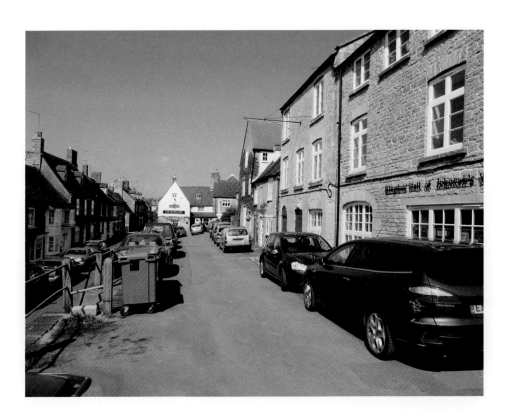

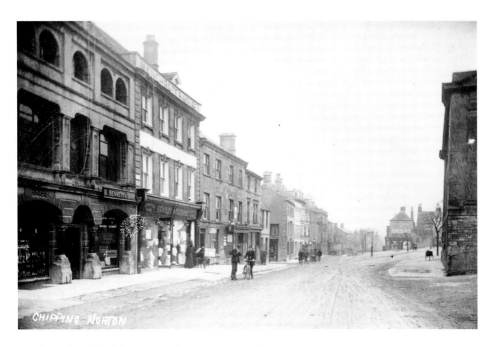

Market Place looking towards New Street Corner.

The imposing building on the left is Hewitt's shop. Next door is Manchester House drapery followed by the old post office. Two postmen are depicted, one with his bicycle. Mr Bignell's bakery is on the opposite side of New Street.

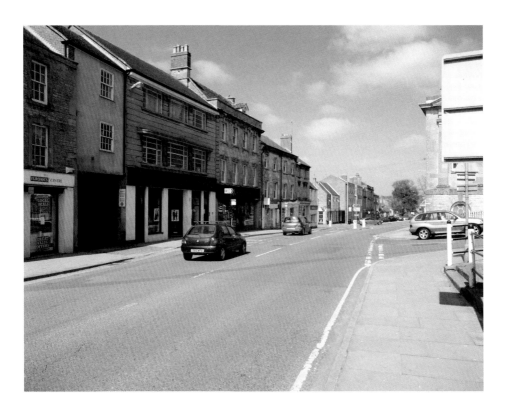

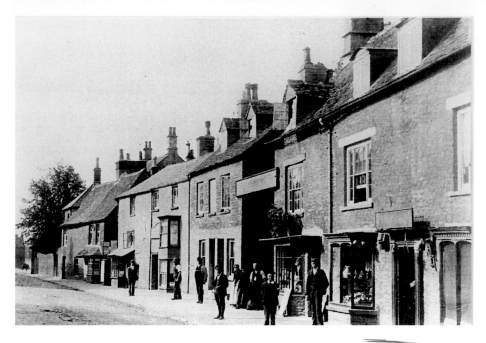

West End.
The north side of West End, looking towards Churchill. The Bon Marche store is near the camera.

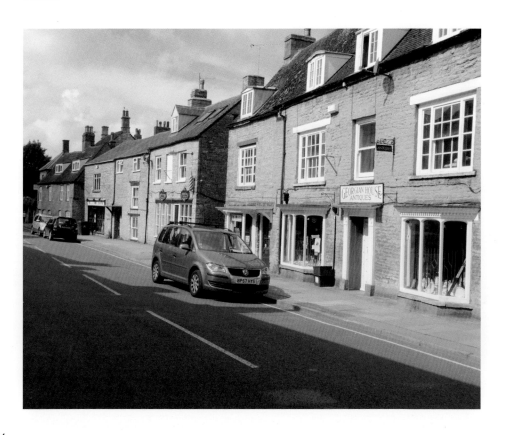

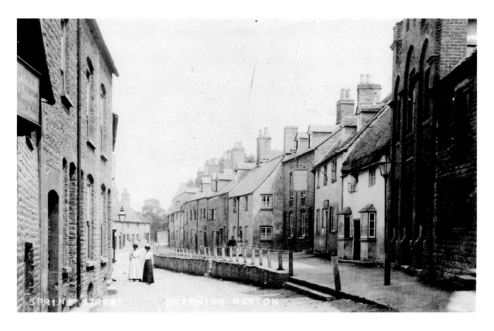

Spring Street, also known as Tite End.

The building on the right, now occupied by the theatre, is the citadel of the Salvation Army. Next door is the last remaining thatched roof in the street. In 1880 all the houses in the street had thatched roofs. Then comes the Ship and Anchor Public House. Much of the street remains the same as seen in this picture of the early 1900s.

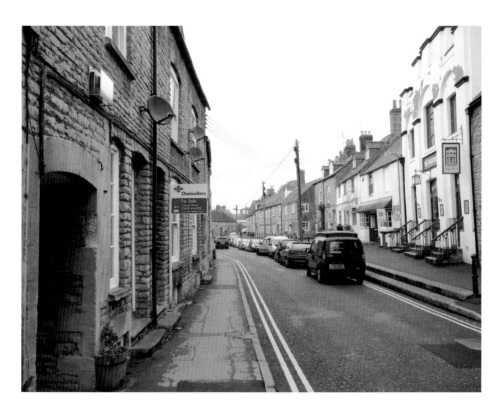

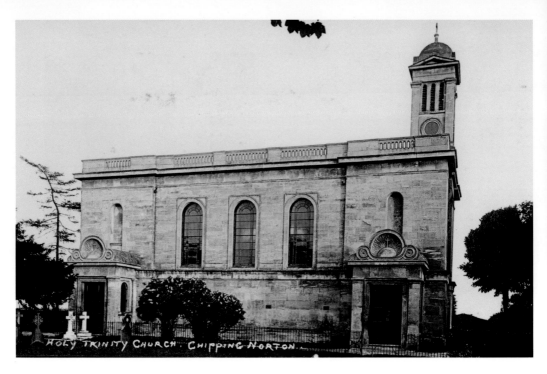

Holy Trinity Roman Catholic Church.

In 1963 the bell tower was considered to be unsafe; and in 1965 it was judged to be beyond repair. A photograph of 1966 shows that it had been removed by that date.

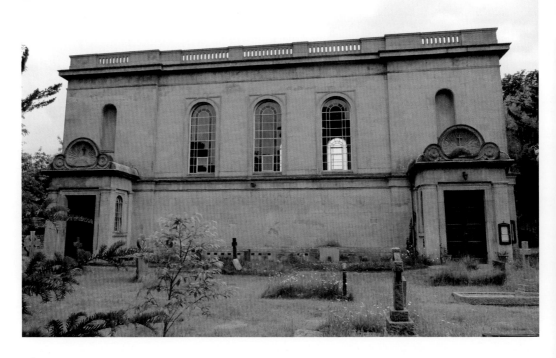

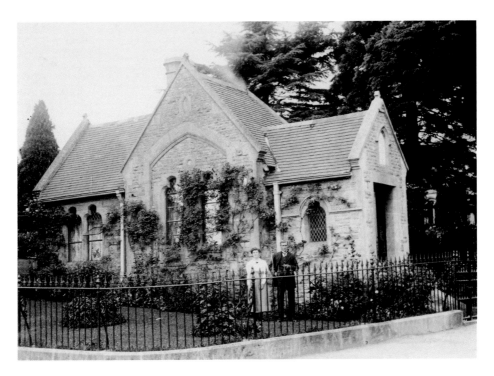

Cemetery Lodge.

Cemetery Lodge at the entrance to the town cemetery in Worcester Road. William Bliss gave the ground to the town for use as a cemetery. The caretakers were Mr and Mrs Titcombe.

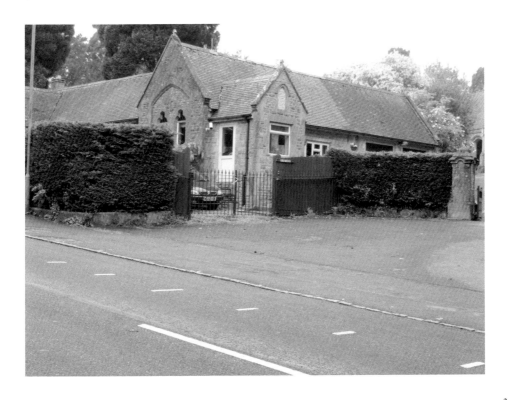

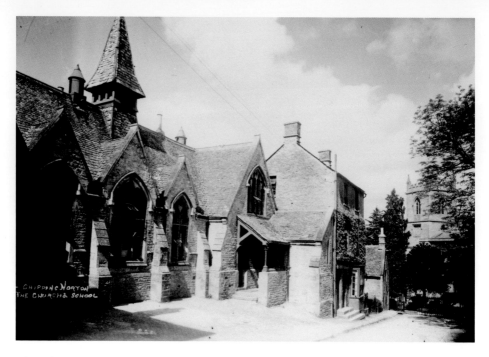

Church Street.

The Church of England Boys' School and the headmaster's house next door. This remained as a school until the 1960s when it was turned into a private house. It has been since been used as a vicarage for several years.

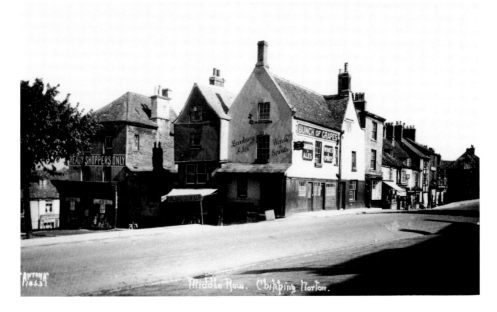

The Bunch of Grapes Inn.

The photograph shows the inn before several alterations to the building were carried out. To the left is 'Rocky' Leach's sweet and rock shop and below that is the drapery and haberdashery shop belonging to the Fitzgibbon family. This was a shop where you could buy literally anything! It was also known as the S.S., or Single Service shop. The initials were in the floor in the front entrance.

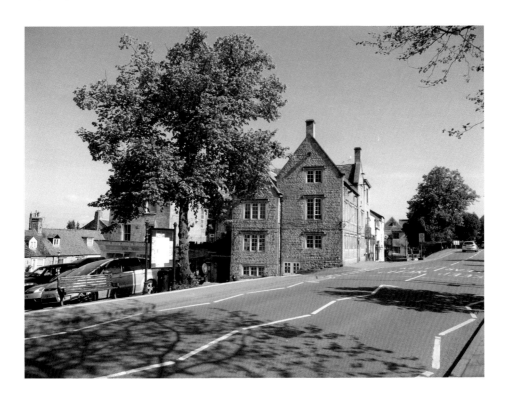

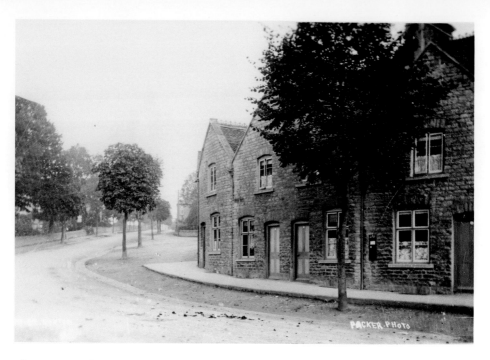

The Corner of Horsefair turning into London Road.

These cottages, known as Cocks Row, were left to the town for the use of elderly residents. Later, in the 1980s, they were turned into flats. Their entrances are now to the rear.

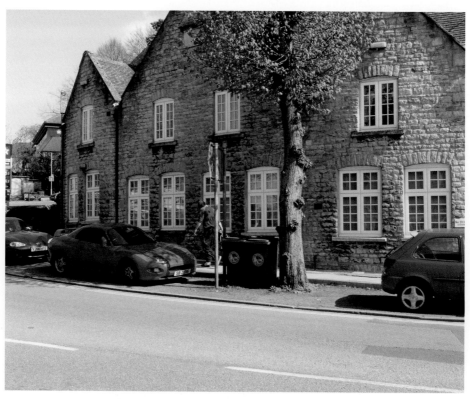

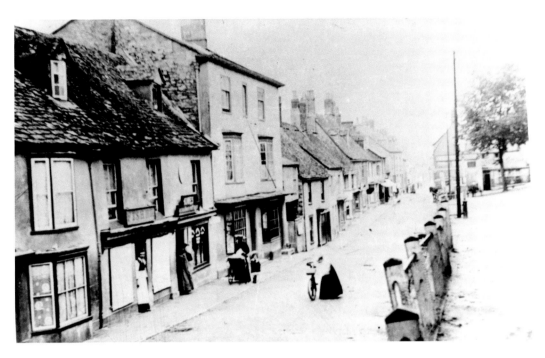

Market Street.
Market Street leading to Spring Street showing the shopfronts in Edwardian times. Many of the shops are now offices and private housing. Cars have now taken the place of pedestrians.

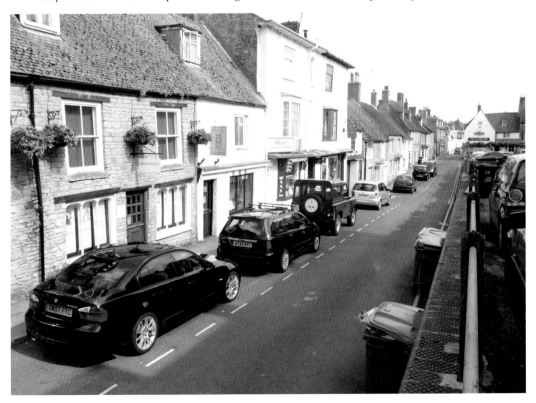

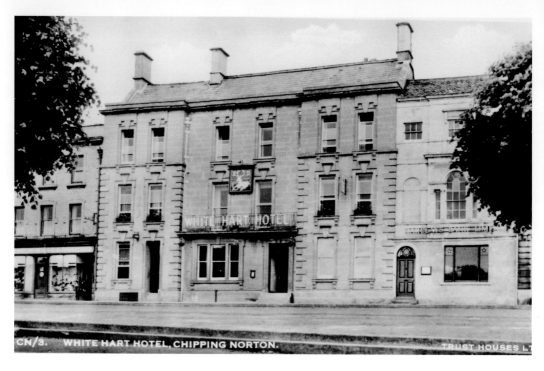

The White Hart Hotel.
The archway led to stables at the rear of the hotel, which pre-dated this photograph. It has since been restored. and been developed into shops and private housing. The building of Barclays Bank, previously Gillett & Co., was known as the Medical Hall in the nineteenth century.

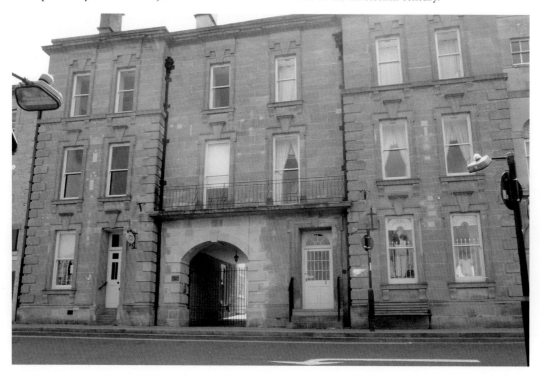

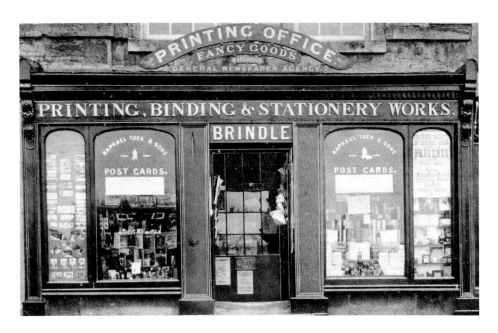

The front of Brindle's Printing, Binding and Stationery Shop.

This was owned by William and Henrietta Brindle before being handed down to their son Arthur. It was later taken over by Mr Alec Hawtin, a long-time employee, and it is now the Cheltenham & Gloucester Building Society office. Brindle's also had a lending library scheme, which was very popular.

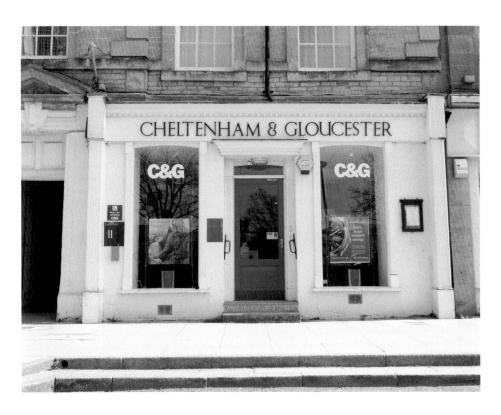

The Telephone Exchange.

This building is on the corner of the road opposite the hospital, at the junction of the Banbury and Over Norton roads. It was built for Folland's aircraft factory during the Second World War; became a Labour Exchange after the war, and it is now the local telephone exchange. Behind it, in the field, were the Town's End allotments. Note the base of a wayside cross to the right of the entrance. It is now the base to the column of the old Market Hall, which can be seen outside the Town Hall.

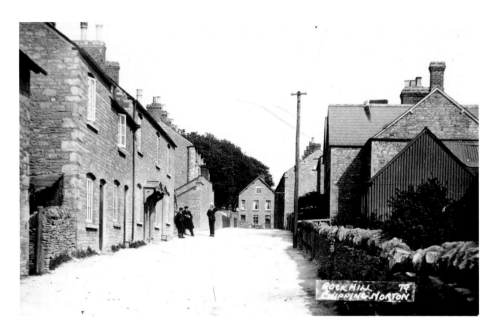

Rock Hill.

Looking towards the top of Rock Hill, formerly known as Windmill Lane. It had a mill at the top until the mid-nineteenth century. Behind the cottages on the right was Padley's Quarry, where the strata of Jurassic Rock known as Chipping Norton limestone was extracted for local building stone. The quarry was popularly known as the Dinosaur Quarry because of the Cetiosaurus fossilised leg bones found there. The large house at the top was once occupied by Albert Morris the basket-maker and his large family.

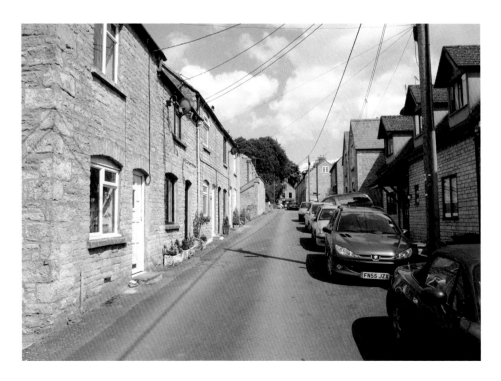

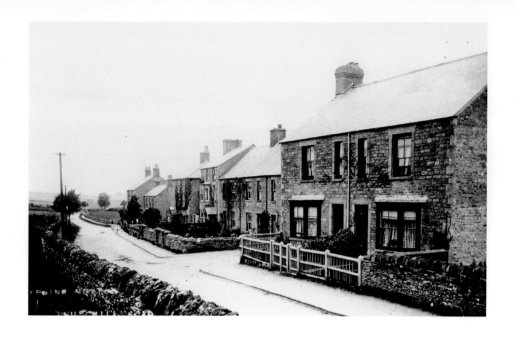

Churchill Road.

Churchill Road, showing the houses at the corner of the road leading to The Leys. On the left-hand side of the picture is the Cotswold-stone wall in the field known as Weston's field.

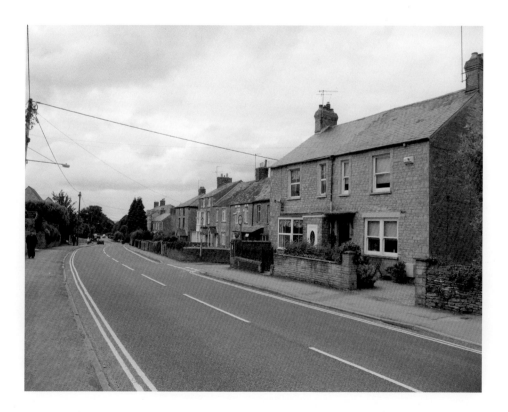

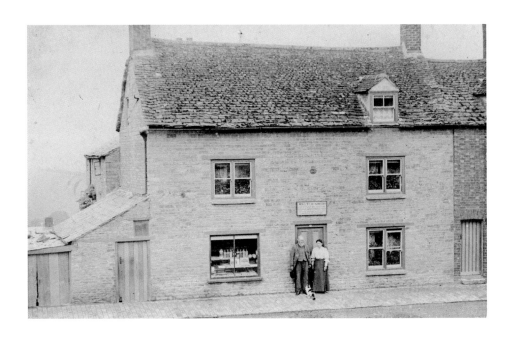

Mr and Mrs Smith standing outside their Sweet Shop in West Street.
This was later occupied by their daughter and son-in-law, Mr and Mrs Lane. It is now the studio and home of Mr and Mrs Fisher.

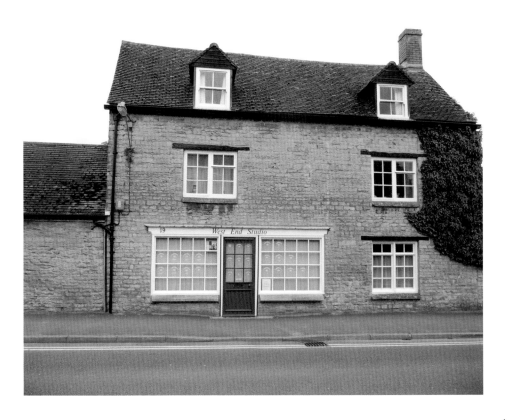

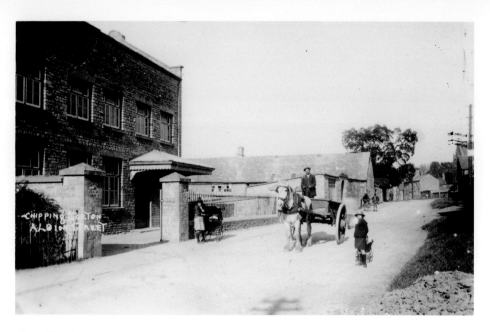

The Chipping Norton Co-operative Society.

Albion Street showing the Chipping Norton Co-operative Society's purpose-built bakehouse, from where they supplied cakes and bread to their shop in the High Street. The man driving the horse and cart is John Shadbolt, a carter and an employee of Burden & Sons, Builders. It is now the car park to the Co-op Supermarket.

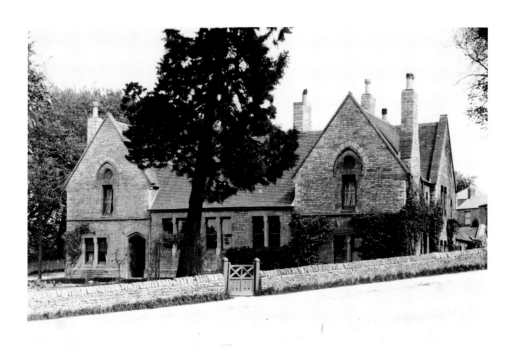

The Police Station.

The police station in Banbury Road. It is the oldest working police station of the Thames Valley Force.

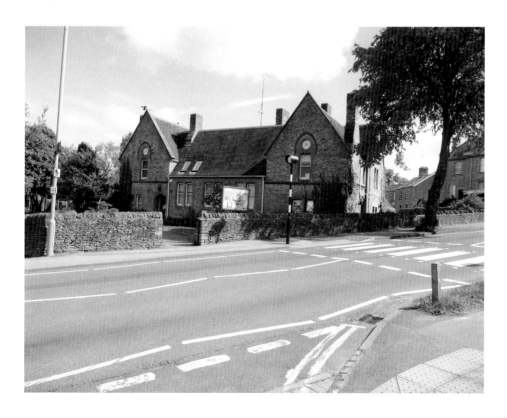

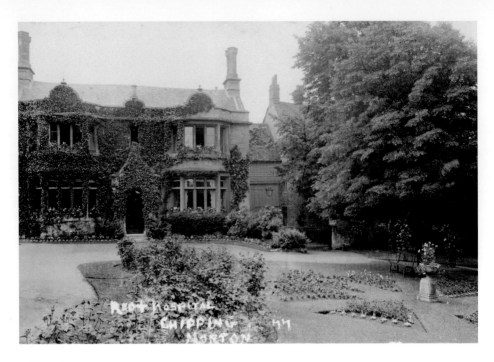

Hill Lodge.

This shows Hill Lodge which was used as a Red Cross hospital in the Second World War, and was later given to the town as a War Memorial hospital in 1919. The hospital was later enlarged, and gained an operating theatre, a maternity unit and more extensive wards.

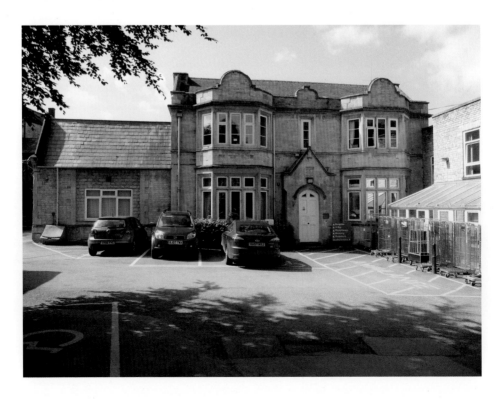

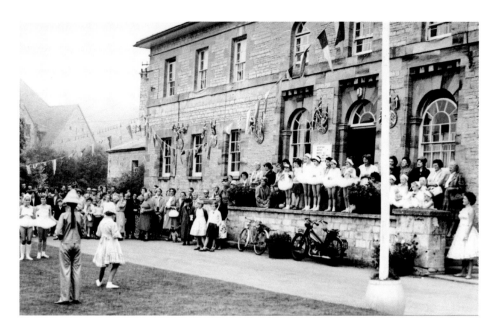

The Workhouse.

The workhouse was erected in 1831 and was a home for 230 paupers. The workhouse had previously been located in Church Street in what is now Redrobe House. This was in use until 1832 when the residents were transferred to the new building. In 1857 rooms for the Master were added and also a chapel built, which was opened by Bishop Samuel Wilberforce. With the creation of the welfare state in 1948, it became Cotshill Hospital. It is now a private housing estate.

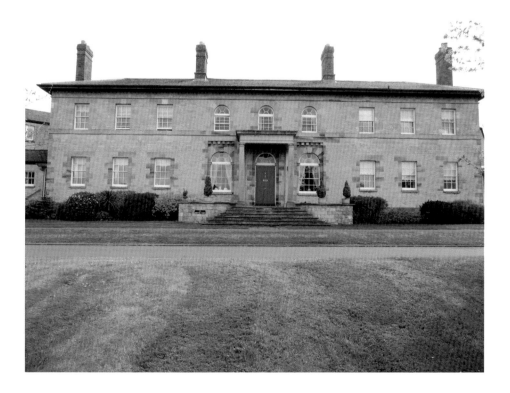

Bignell's Bakery and Restaurant.

The top of New Street showing Mr Bignell's bakery and restaurant. This picture shows how narrow the road was at this junction. Mr Bignell always had a wonderful display of cakes and buns in this window and occasionally a stunningly iced three-tier wedding cake complete with a silver stand. The top of New Street at Bignells corner was always a meeting place for the people of the town.

The Cattle Market.

The Cattle Market looking towards the Co-operative delivery warehouse. Through the gates on the left was the Co-operative garage where the delivery vehicles were maintained by Roy Williams, George Lane and their crew. They also serviced private vehicles.

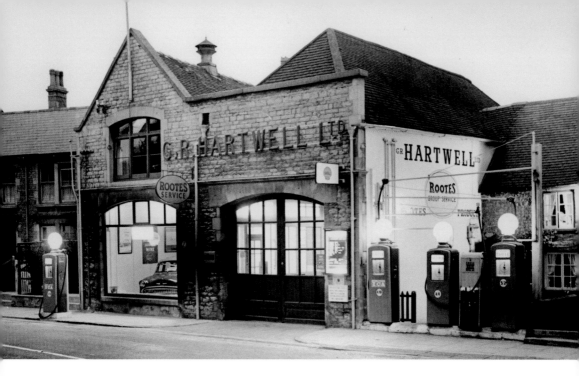

The Horse Fair.
Hartwell's garage was the fore-runner of Hartford's, the national garage network. Central Tyres is now on the site.

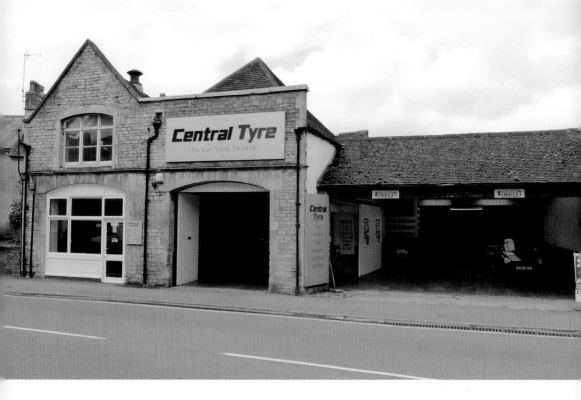

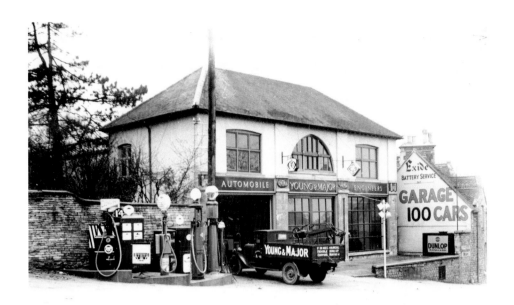

Young & Major's Garage.

The garage was on the corner of London Road and Albion Street. Mr Young emigrated to Australia and then Mr Bob Major and Mr Sholto Major owned the garage. The Chipping Norton ambulance was stationed there twenty-four hours a day and the staff, mainly Ernie Morris, drove it. The Spar shop and filling station is there now.

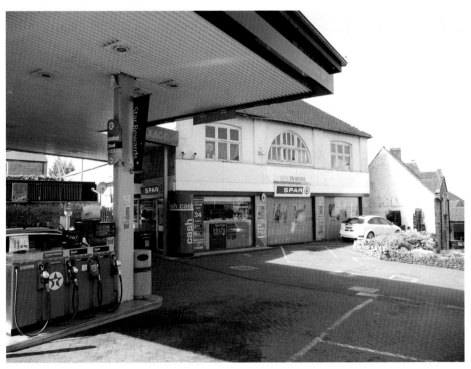

Walterbush Road.

This was named after the farm it led to. At the time it was referred to as Water-bush road because it was always wet and muddy!

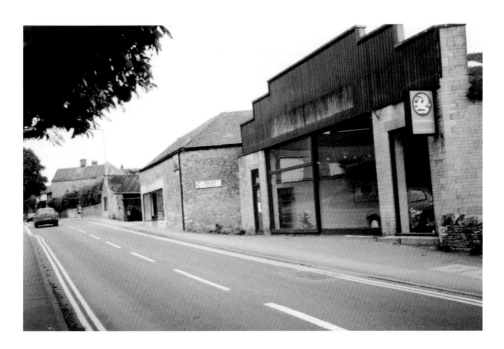

The Car Showrooms on the Burford Road.
Burford Road, showing the car showrooms and shop belonging to A. Ambrose.

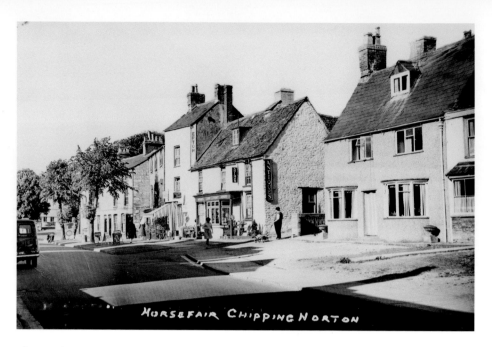

The Bugle.

The Horse Fair showing the old public house called the Bugle. The alleyway led to Stanley's yard and Portland Place.

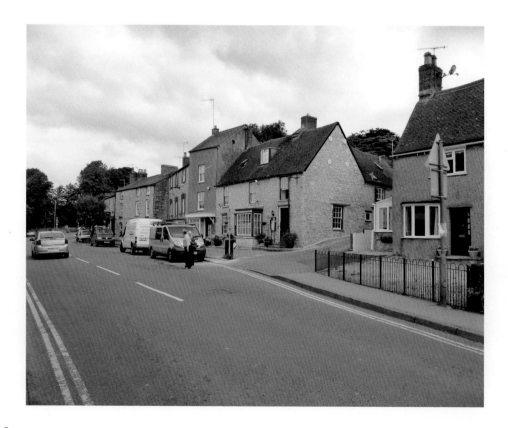

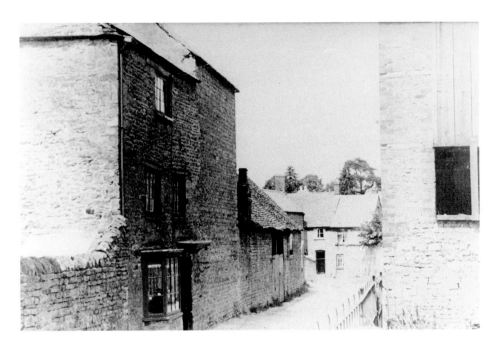

The Apiary.

Distons Lane, showing the house called the Apiary, once occupied by the Burbidge family. The outbuildings shown were originally part of the old tannery. The Fry, Cox and Siggars families once occupied the cottages in the centre of the picture.

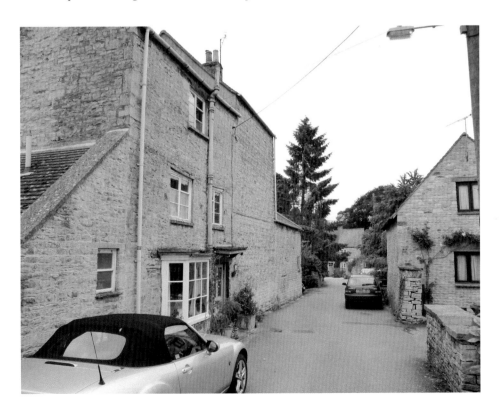

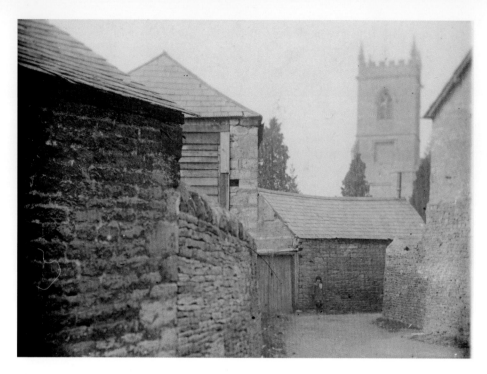

Distons Lane.

At the bottom of Distons Lane looking towards St Mary's Church. The buildings on the left belonged to the tannery business located in the lane. The white railings were part of the old cattle market. They bear the town crest and the name Sidney Lewis.

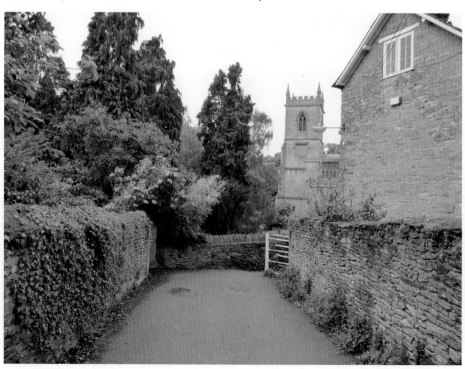

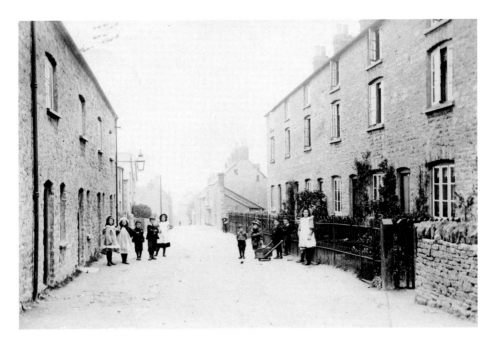

Rock Hill.

This picture shows some of the children who lived here. The houses on the right were owned by the Oddfellows Society. Notice the modernisation of the street lighting.

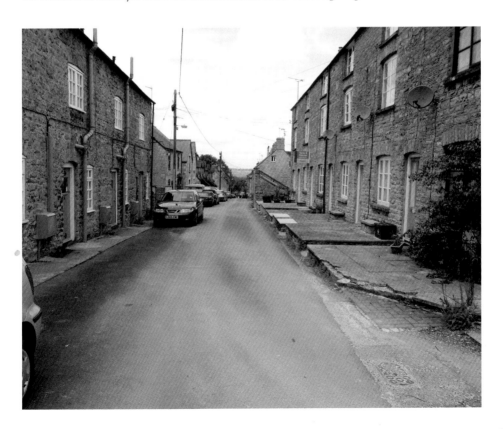

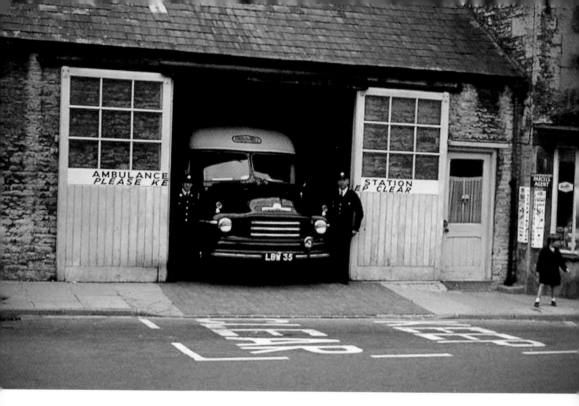

The Ambulance Station.
Previously used as a Fire Station, it is now Malpass the florists.

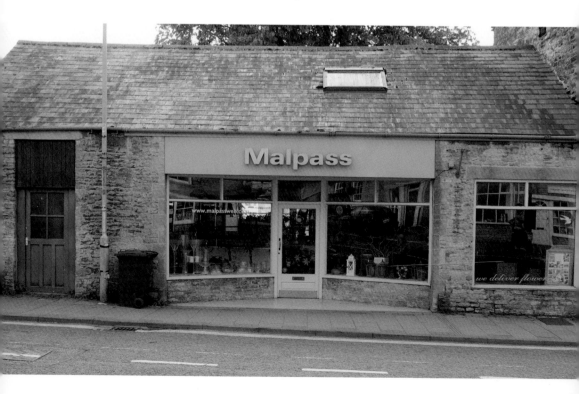

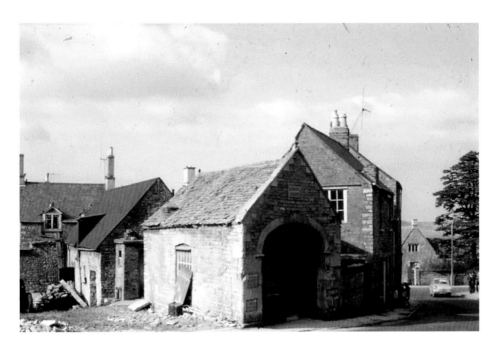

The Old Engine House.

The old Engine House in Burford Road, which was built in 1878 to house the new horse-drawn pump fire engine, almost opposite the junction with Albion Street. It was demolished to widen the road at the junction with West Street and Burford Road. The plaque stating it was the Engine House is now incorporated in the new fire station in Burford Road.

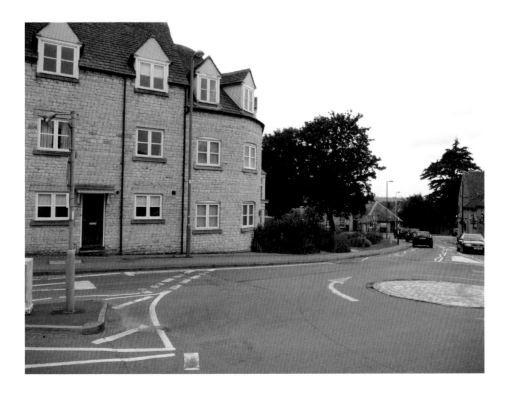

St Valentine's Day.

These children are celebrating St Valentine's day in Chipping Norton. An old custom was to go around the town early in the morning singing the rhyme 'please to give me a valentine, I'll be yours if you'll be mine'. The children are gathering outside the Blue Boar Hotel and you can just see the landlady throwing hot pennies out to them. The central road, Goddard's Lane, was known as The Bricks. In the background is the Guildhall and to the side is an old building which was used to sort the Sunday papers until it was demolished to make way for the new library.

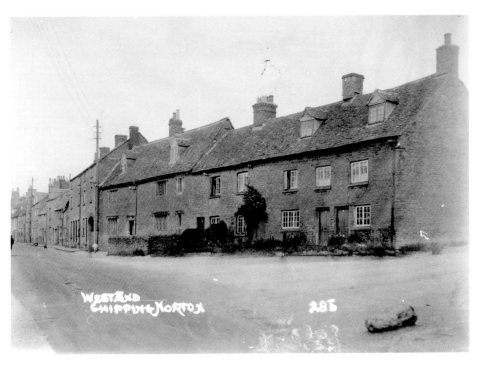

West End.

The cottages were owned by the Aldridge family. There is an alleyway to College Place. The land belonged to Brasenose College.

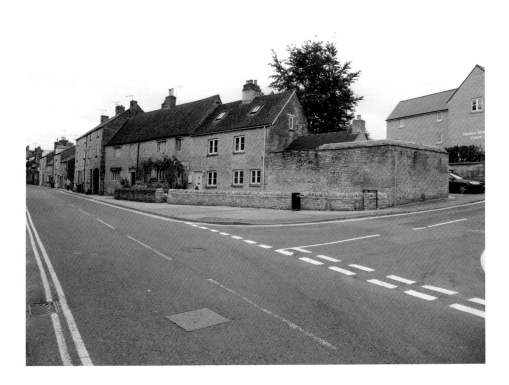

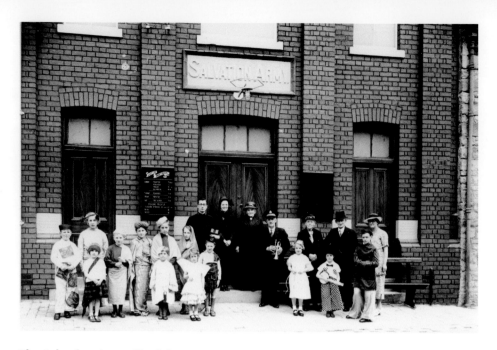

The Salvation Army Citadel.
A gathering outside the Salvation Army citadel in Spring Street. After the closure of the local branch of the Salvation Army, this building was a second-hand furniture storeroom. It was bought and refurbished as a theatre by John and Tamara Malcolm, and has gained a national reputation for its pantomimes.

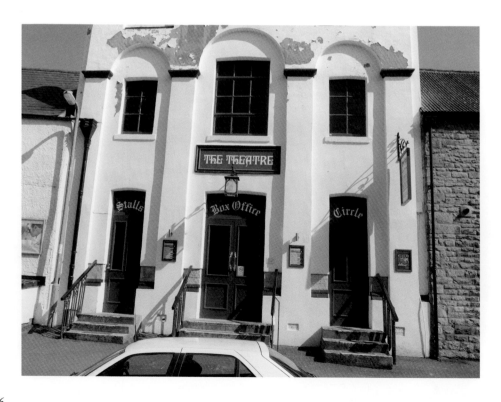

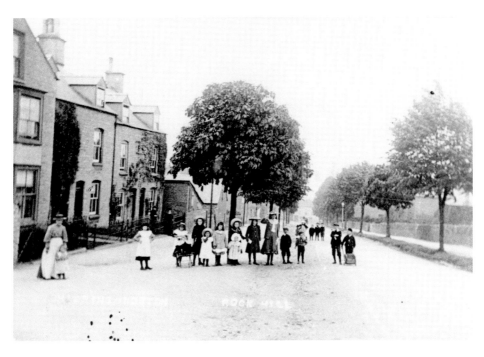

The London Road.

Children are standing in the middle of the London Road in Edwardian times. The wall to the workhouse garden is to the right. Note the new houses being erected in Cotshill grounds.

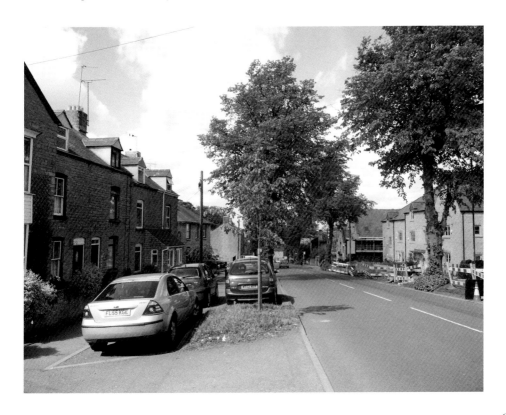

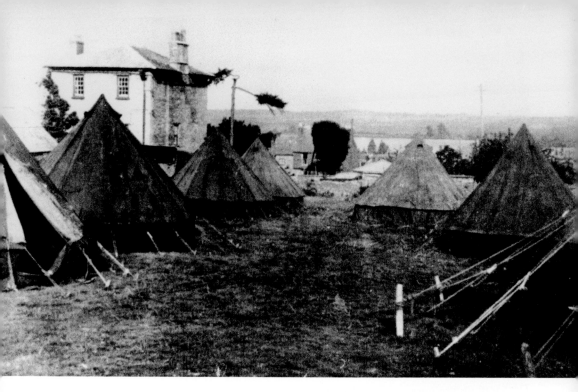

The Agricultural Camp in Albion Street in 1946.
City people stayed here and worked on the farms at haymaking and harvesting time. It is now Fox Close.

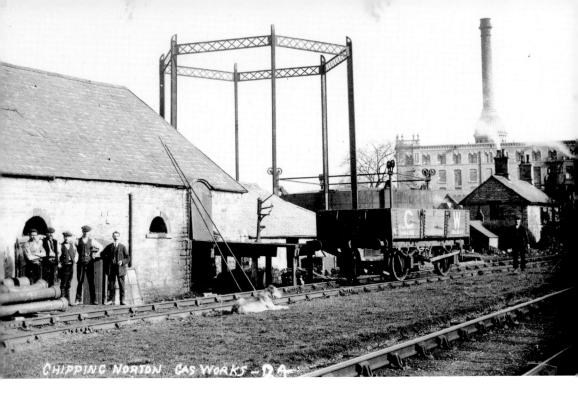

CHIPPING NORTON GAS WORKS - DA -

The Gasworks.

The Gasworks by the railway near to Bliss Mill. The only building remaining today is the cottage.

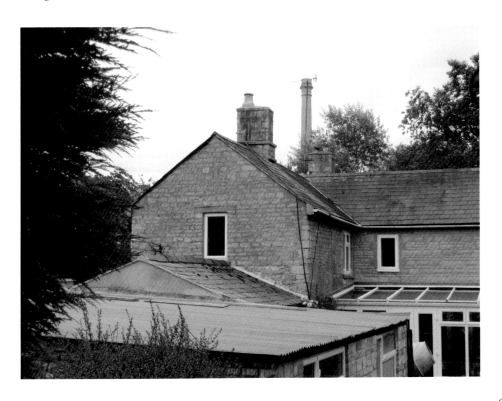

The Waggon and Horses.

Mr Hall and his family standing outside their public house, the Waggon and Horses, in London Road. The gentleman with the dog and gun has obviously been shooting on one of the local farms in that area.

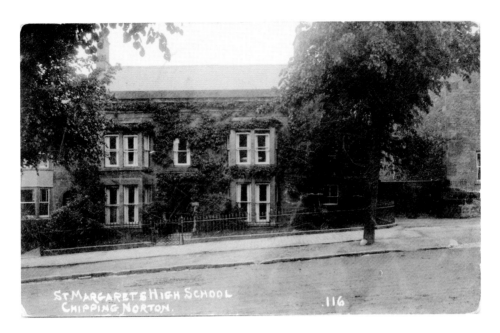

St Margaret's School.

St Margaret's School at 35 New Street. In the late nineteenth century the Misses Treble opened a school for girls and a kindergarten. The school curriculum consisted of religious studies, reading, writing, arithmetic, mathematics, English grammar, composition and literature, history, geography, French, German, Latin, natural science, chemistry, drawing, class singing, needlework and drills. Extra subjects included piano, violin, organ, solo singing, dancing, gymnastics, painting, elocution and fancy needlework. It was purchased by Mr Adolphus Webb in 1920 and became his family home until the 1970s when the last member of the family, Miss Sybil Webb, left the area.

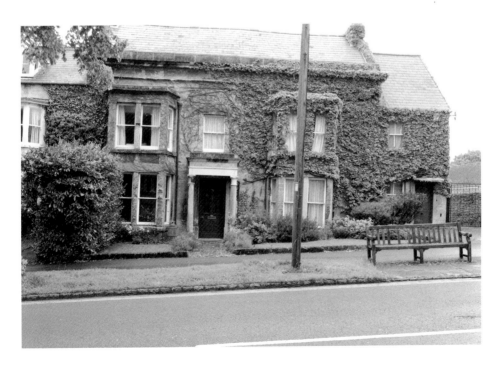

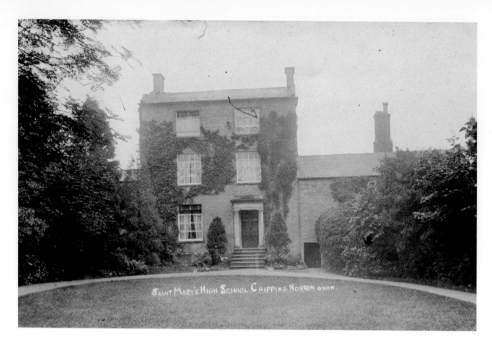

St Mary's High School, Hillside.

St Mary's High School in Albion Street was a private Church of England school situated just behind the garage at the far end of Albion Street. It was used by soldiers in the Second World War and, later, as the offices of Chipping Norton Rural District Council until the Council moved to Greystones.

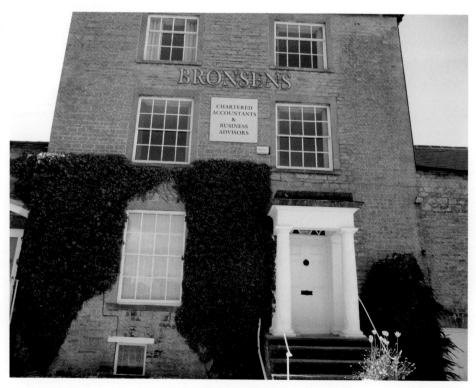

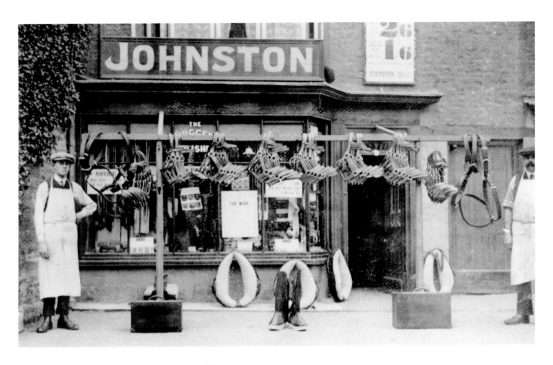

Johnston's Saddlery Shop in West Street.

Mr Johnston's father started the business and it was eventually taken over by his sons. After Reg Johnston retired, it became Brown's bakery and now it is the Anarkarli Indian restaurant.

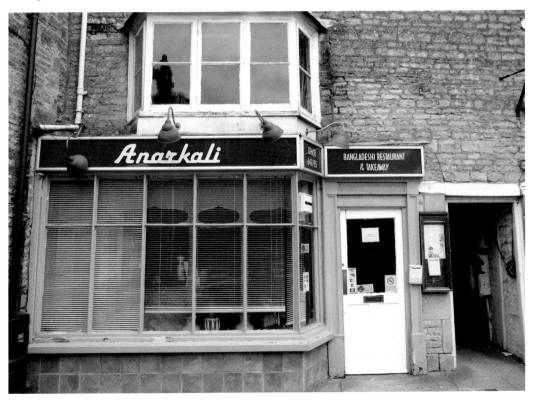

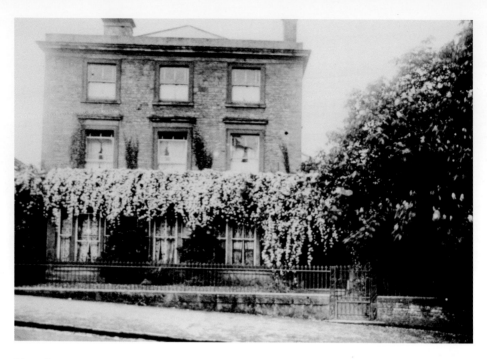

New Street.

The was William Bliss's home, later occupied by Mr Dunstan. The stone of the house was used in the building of the flats which replaced it.

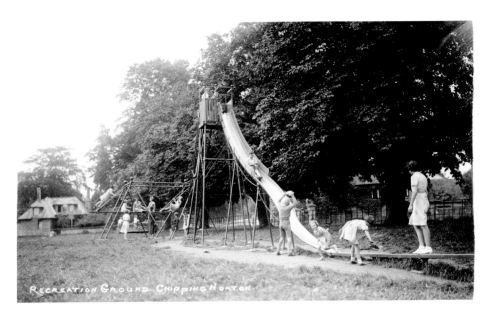

The Children's Playground on the Common in New Street.

The equipment was bought and erected in 1938 and was appreciated by the children in the town. Football and cricket matches were played there. Eventually, a shelter and toilets were placed upon the Common but these were taken away after attacks of vandalism. The old playground equipment stayed there until Health and Safety rules came into force and the slide was deemed too high and the American swing too dangerous. The chestnut trees by the side of the road were also popular for climbing!

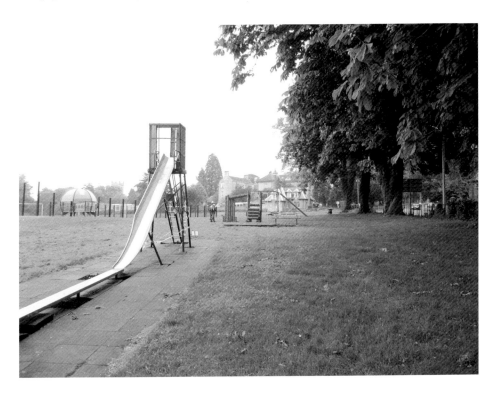

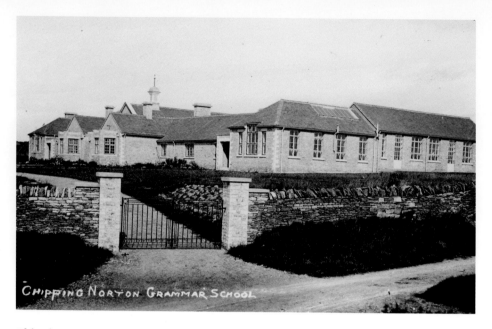

Chipping Norton Grammar School.

This was opened in May 1928 as a grammar school for North Oxfordshire. Pupils from Chipping Norton, Woodstock, Charlbury, Stonesfield and nearby villages who passed the scholarship examination, attended this school. It was also a fee-paying grammar school. On the left of the picture is the main entrance reached via a long drive with flowerbeds on either side. The large building on the left was the science laboratory.

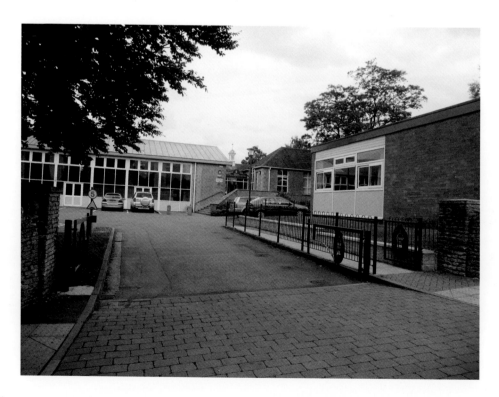

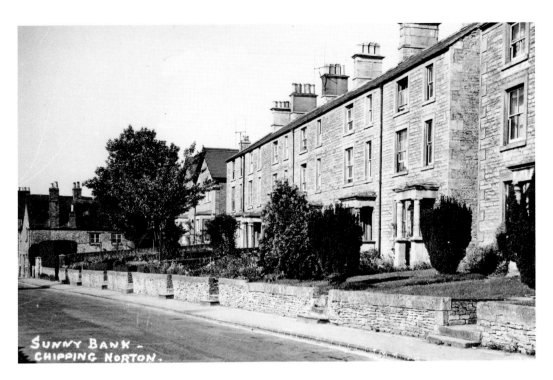

Sunny Bank, West Street.

These houses were built by Thomas Burden for his workers. In recent years the front gardens have been converted into well-designed hard standing for cars.

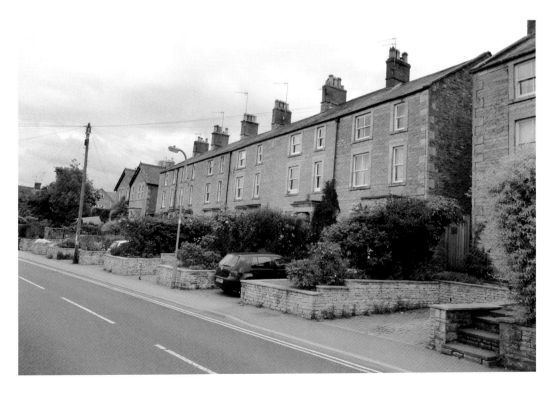

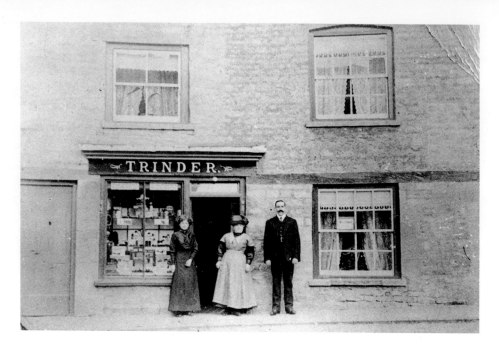

Trinder, West Street.

Mr and Mrs Trinder kept their shop in West Street next to Mr Johnston's saddlery shop. This eventually became the home of Mr and Mrs Johnston until their retirement. It had previously been a taxidermist's owned by Mr Coombs. It later became a bookshop with several owners, including Elizabeth Coyne, Elizabeth Sleight and Jaffe & Neal. It is now the charity shop for the Katharine House Hospice.

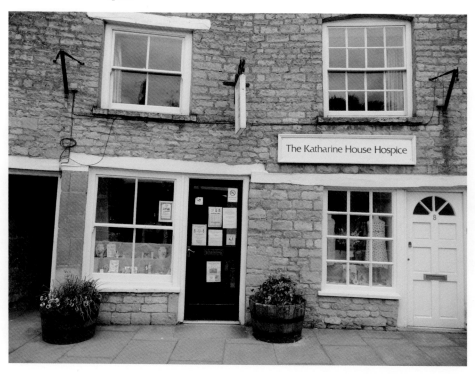

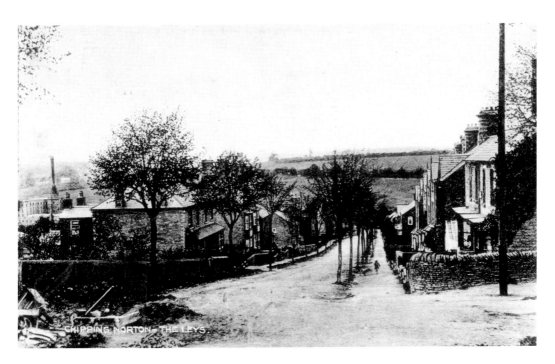

The Leys, shown from the junction with Cross Leys.
There are no longer any lime trees!

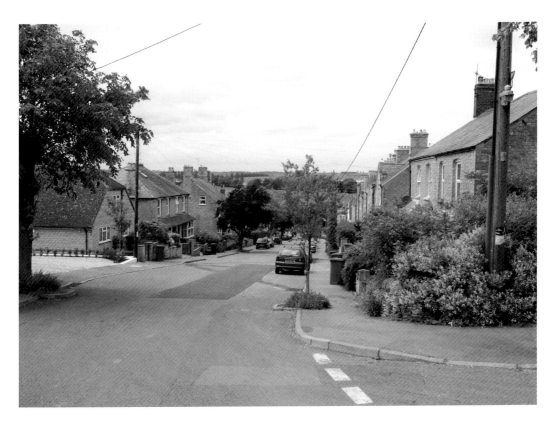

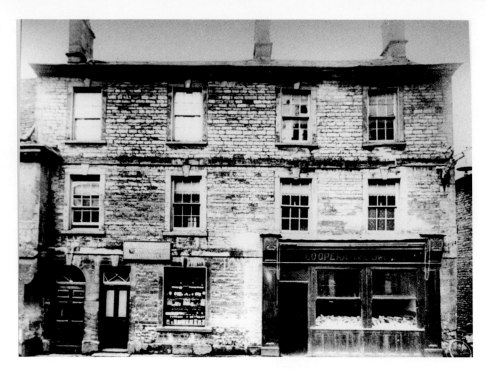

Chipping Norton Co-op.

These premises were divided into two shops, the larger being the butchery department of Chipping Norton Co-operative Society. Later, the whole building became the Old Mill Restaurant.

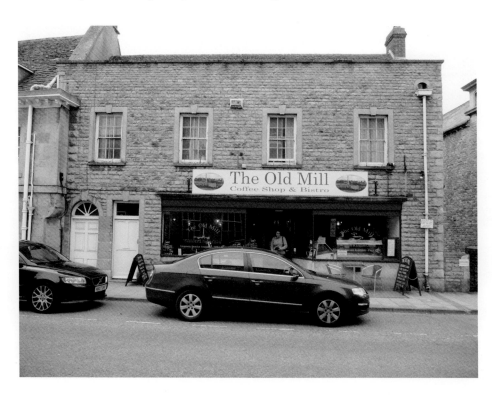

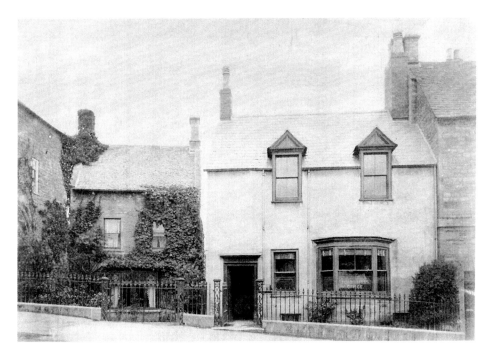

Cinema, New Street.

This house was situated in New Street until the 1930s when it was demolished to make an entrance for the New Cinema. It had been used as offices for the Gas Company. You can just see the Schoolmaster's house next door belonging to the British School. The house door behind the railings is now used as a café. There are now houses on the site of the old cinema.

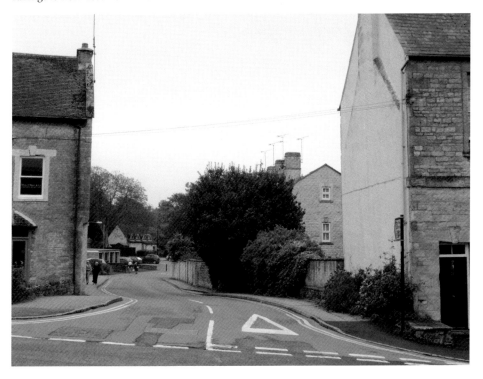

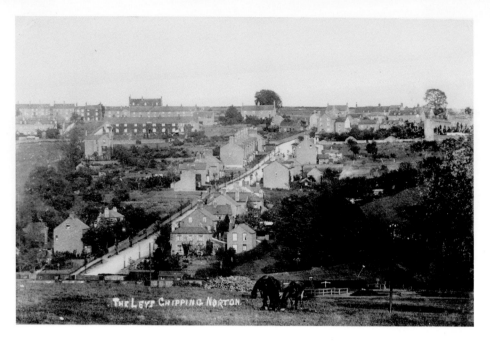

The Leys with Several Vacant Plots.

The railway runs across the bottom of the picture. Children and adults used this hill for sledging during snowy winter weather. The red-brick terrace houses halfway up the left-hand side were built by the Co-op for their workers and called Holyoak Terrace. Mr Holyoak was a leader in the Co-operative movement.

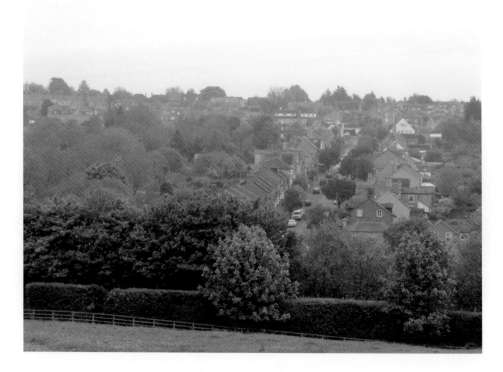

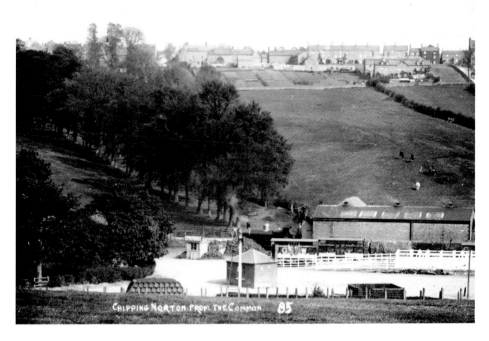

The Railway Station.

The picture shows the old engine house and cattle dock in the railway yard. The line of trees marks the tramway which was the link between Upper and Lower Mill in the 1800s.

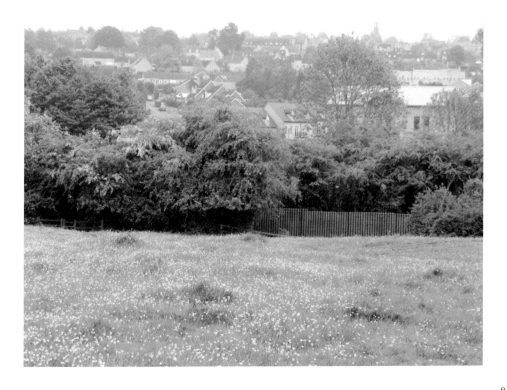

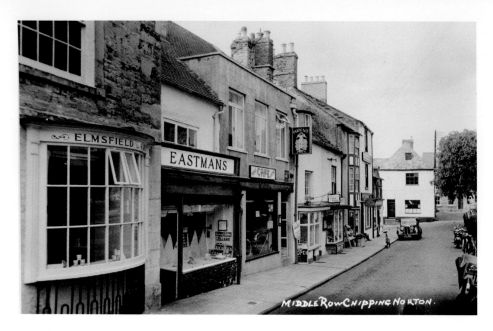

Middle Row in the 1950s.

Tom Duncan sold his fish and chip shop to Elmsfield Dairy. Next door is Eastman the butchers, followed by the Phoenix Café. It was named after a serious fire had gutted the sweet and provision shop owned by Mrs Priestland. Other shops in the row are a grocer's shop, a hairdresser's and, at the Guildhall end, another grocery shop. There is also Simms' music shop and Miss Burbidge's sweet shop.

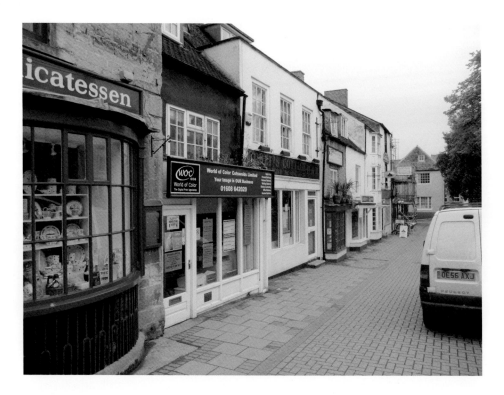

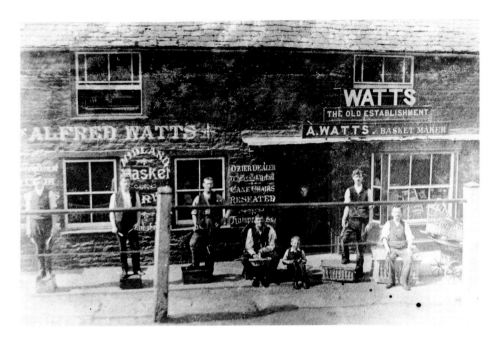

Mr Watts, Basket Weaver, and his Workmen in Market Street.

The business was previously located in the Horse Fair. The gentleman sitting by the little boy in the centre is Alfred Morris, who carried on the business after Mr Watts retired. Mr Morris had premises in the Guildhall and later in New Street, and was the last basket maker in the town. The house is now lived in by Mr and Mrs Michael Howse.

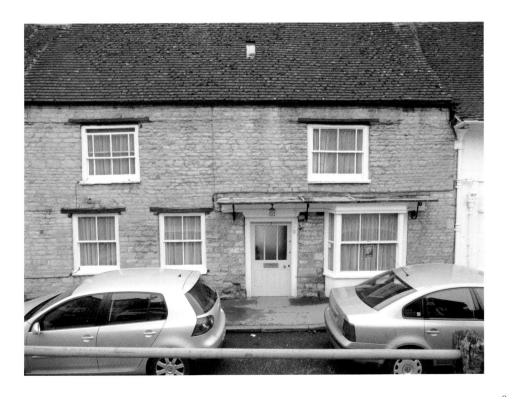

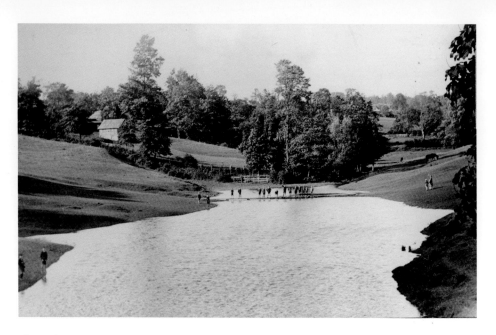

The Lake.
The Common Brook was articially flooded so that it could be used for swimming in the summer months and skating in the winter. The children in the centre are standing on the old stone bridge, which is still in place today.

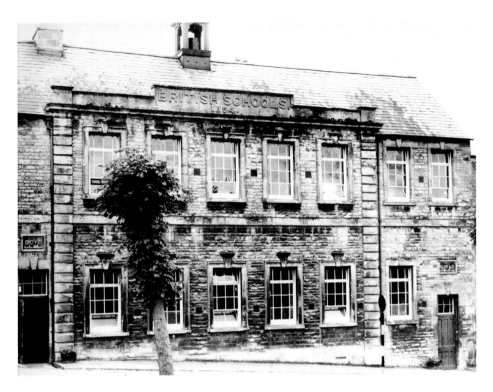

The British School in New Street.

This is near the site of the Manor House. Later, three cottages stood here and when they were demolished the British School was built in 1854 on the site. At the beginning, it was divided into separate boys' and girls' schools. The school closed in 1965 and, in 1972, Richard Vernon founded the Chipping Norton Recording Studios here. Some of the notable bands recording here included Duran Duran, The Chants and the Bay City Rollers.

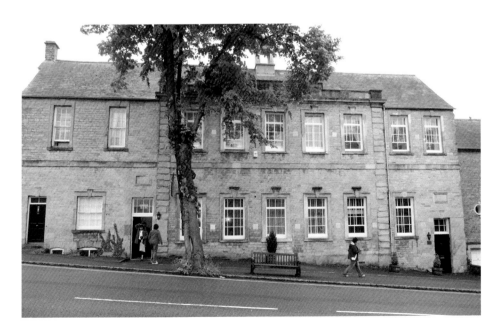

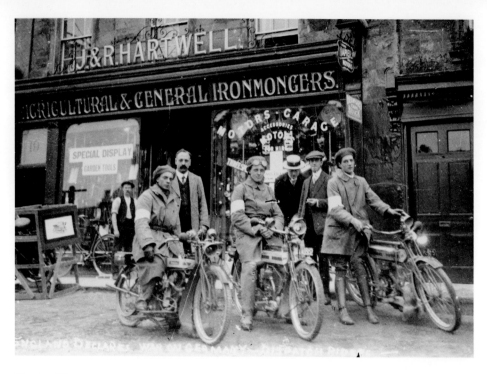

Hartwell's.
Members of a Motorcycle Club outside Hartwell's, High Street. Hartwell's is now the Cotswold Newsagents.

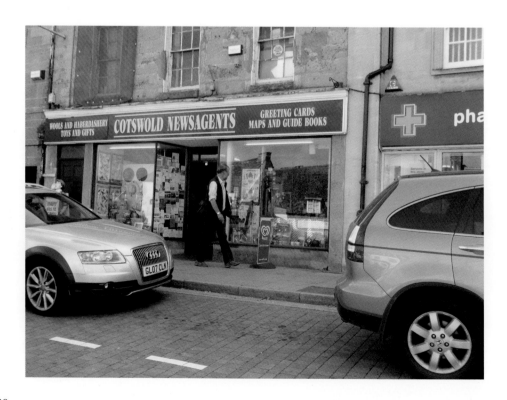

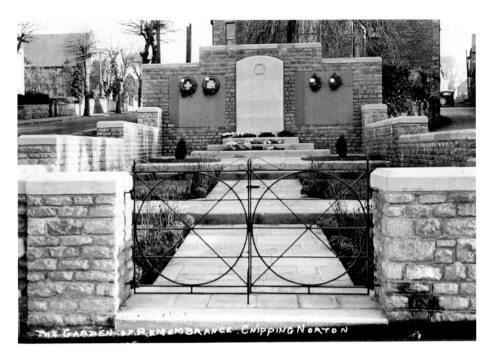

The Chipping Norton War Memorial.
This commemorates the men who gave their lives in the two World Wars.

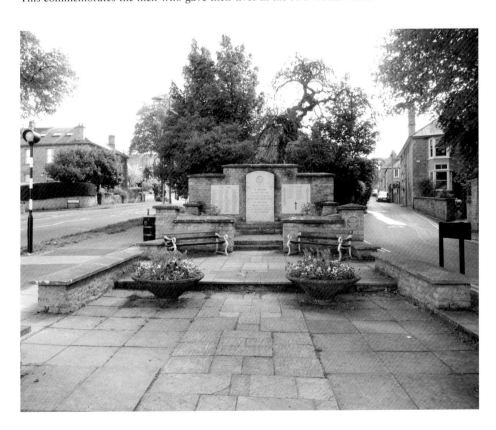

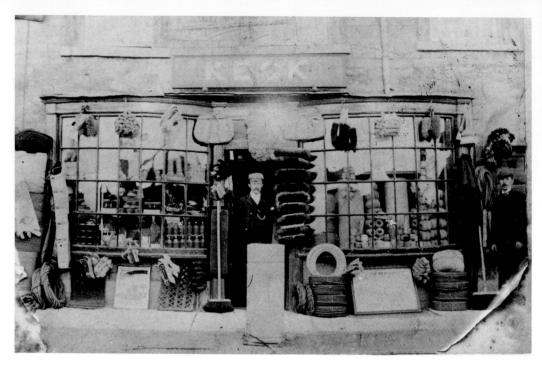

Thomas Keck's hardware shop on High Street.

Mr Keck was also a ropemaker and he once made his longest rope by starting at the Midland Bank, going across the road and through his shop up to Albion Street. Under the shop is a small cellar that dates from the fifteenth century. It has a vaulted ceiling, a window and a door. Later, the shop became Putmans, The Playpen and, eventually, the Post Office.

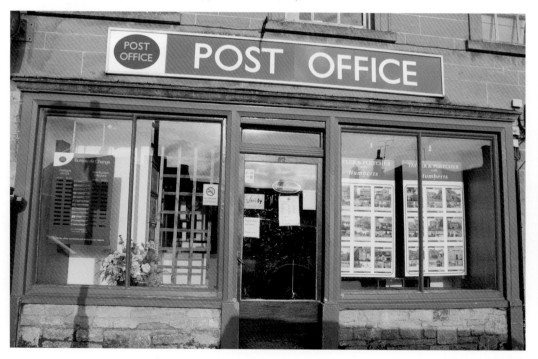

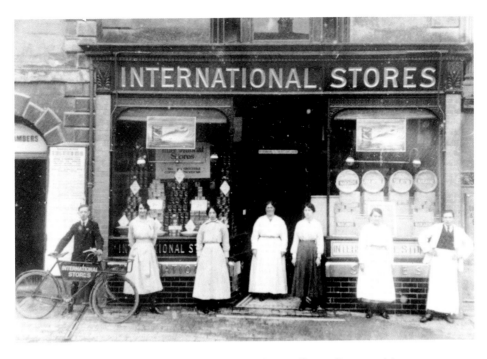

International Stores in Market Street, with the staff standing outside.
The shop eventually moved to the High Street before moving into new premises at the top of New Street. After the move the premises were owned by Vic Cooper, who ran his café here. Granny's Kitchen, as it was known, was popular with the youth of the town.

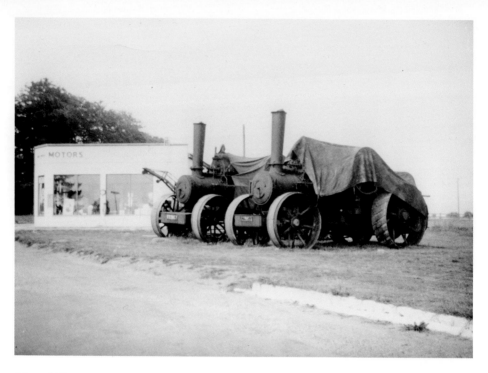

Chapel House.
Neville Melhuish has his pair of steam ploughing engines outside his garage. The Little Chef café which was here has been replaced by Ma Larkin's.

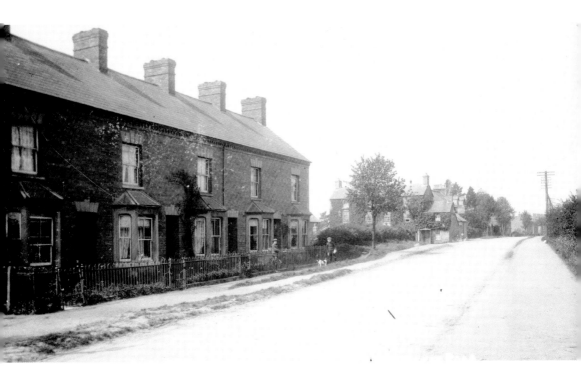

Worcester Road, or Over the Common!
Hedges now replace the railings and the small all-purpose shop at the top of Toy Lane is no longer there.

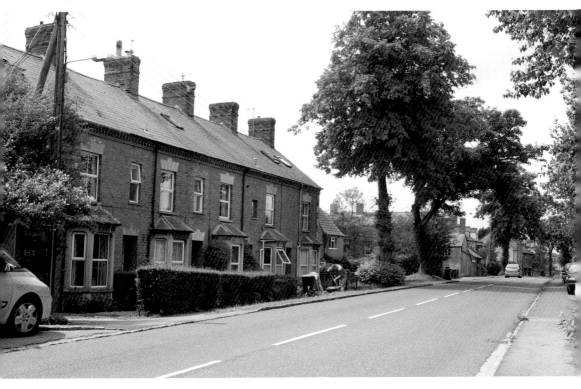

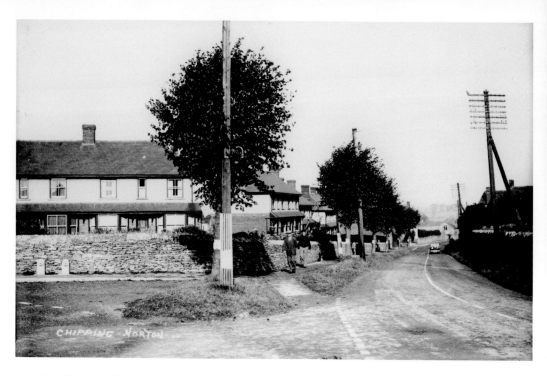

Burford Road.

Burford Road at its junction with Walterbush Road. There is very little change expect for the building of the new Fire Station on the right.

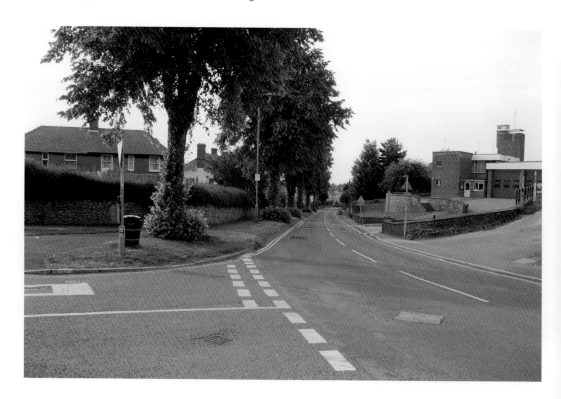

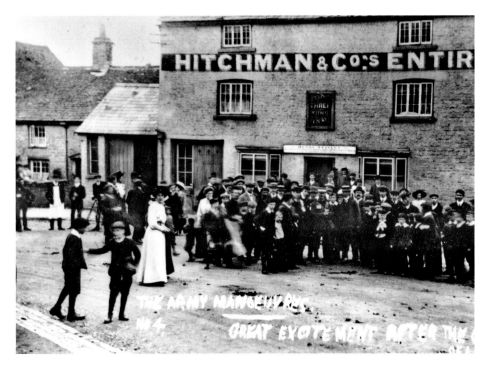

The Oxford House Inn.

The Oxford House Inn which was previously known as the Three Tuns. These manoevers were in 1909 for the training and recruitment for the Army. It caused much excitement with the young lads in the town and district. The Inn is now known as 'Off the Beaten Track'.

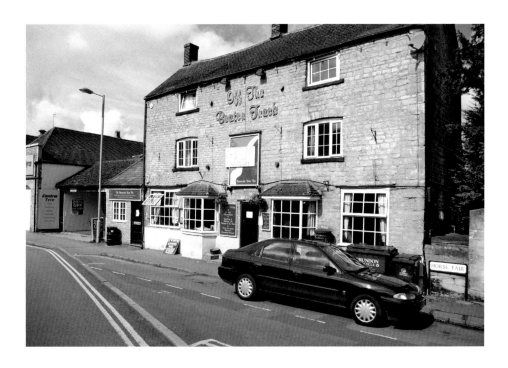

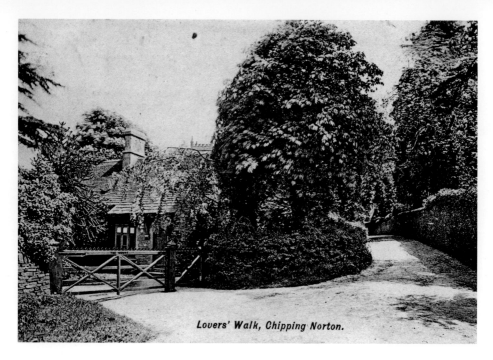

Lovers' Walk, Chipping Norton.

Love Lane.

Love Lane, Chipping Norton, reached a through gate in St Mary's Churchyard or from New Street beside the entrance to the Common. This lane leads to a private house. The house shown in these photographs is at the entrance to The Mount. The Common is also reached by walking down this lane. The wall on the right-hand side belongs to Penhurst School.

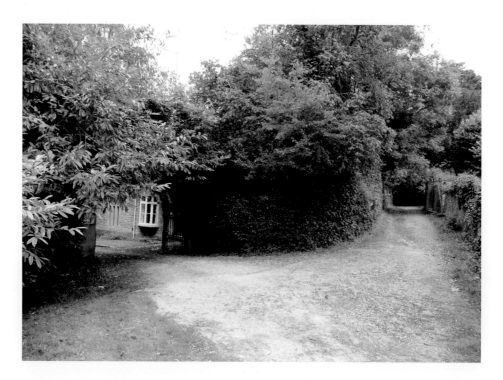